MOSTLY PEOPLE

Erika Stone

MOSTLY PEOPLE

Photographs by a German Immigrant in New York

Kehayoff
Munich

Helmut Hess

MOSTLY PEOPLE

Erika Stone and New York Photography

Anyone who takes an interest in photography can't avoid asking, at some stage, the question: is the observer first aware of the content of the photograph or the medium itself? In other words: do we ignore the surface of the photograph in order to see, as it were, the content of the photo behind it; or do we remain aware, as Vilém Flusser stated, that technical images are not windows but images?[1] In the case of Erika Stone's photographs, I am convinced that the eye is first led to the subject of the photograph, captured by the camera in a documentary style. This type of photography confirms Roland Barthes' theory of photography as pure contingency: "Whatever else a photo reveals to the eye and however it may be structured, it remains invisible: it is not the photo that one sees"[2], rather the thing itself. This dualism, originating in the referential identity of the medium, is what makes working with photography so exciting, for the photograph always has to prove first what sort of image it wants to be. Erika Stone's photographs are not the subject of their own work, rather they appear as representatives of real life. This places them in a definite photographic tradition, that we will look at more closely below.

Erika Stone, née Klopfer, came to New York at the age of 12. She emigrated with her parents from her native city of Munich in 1936. National Socialist Germany had become an existential threat to the family with its Jewish ancestors. Erika Stone originally wanted to become a fashion designer, but the family's pressing financial needs meant that this choice of career was out of the question. In its place she began to channel her passion for photographing everyday situations into a professional career. As a ten-year-old girl she had had a simply Box Brownie type camera and had astonished her relatives with her photos. In New York her photographic ambitions took a more concrete form when her father, who had noticed his daughter's photographic talent, gave her his own Voigtländer Superb, a medium-format twin-lens reflex camera, as a present.[3] At the age of sixteen she photographed the neighbourhood children and sold the portraits at a profit to their parents, who either engaged her for further portrait sessions or recommended her to their friends.

Her first modest entry into the world of professional photography came about through the German photographer Fritz Henle[4], who was a friend of her family. He

1 Vilém Flusser, *Für eine Philosophie der Fotografie*, Göttingen 1994, Das technische Bild, p. 13ff.

2 Roland Barthes, *Die helle Kammer*, Frankfurt/Main, 1989, p. 14.

3 The camera was first presented at the Leipzig Trade Fair in the Spring of 1933. Its novel construction caused a sensation.

4 Fritz Henle (1909–1993) studied at the "Lehr- und Versuchsanstalt für Photographie" in Munich on the recommendation of Hanna Seewald, who had noticed his photographic work. He emigrated to the USA in the same year as Erika Stone. He worked as a freelance photojournalist for different magazines, such as *Life*, *Fortune* and *Harper's Bazaar*. From the 50s onwards he was well-known as a photographer of nudes.

got her a job in the well-known photographic laboratory Leco, however only as a "gofer" (go for coffee) at first, for a meagre $12 a week. Yet Erika Stone made the most of the opportunity: she was soon allowed into the darkroom and made a favourable impression on the company boss, Leo Cohn. She also came into contact with numerous photographers, such as Robert (1913–1954) and Cornell Capa (geb. 1918), David Seymour (1911–1956), better known by his pseudonym Chim, and Philip Halsman (1906–1979), who were among the laboratory's clients. The photojournalist Cornell Capa, who immigrated to the USA in 1937 and founded and ran the "International Center of Photography" in 1974, was a particularly careful observer of her photographic ambitions. His documentary view of the world didn't remain without effect on the young photographer. The same applied to Chim, who came to the USA in 1939 and who, together with his friends Henri Cartier-Bresson, Robert Capa, George Rodger and William Vandivert, founded the legendary international photo agency "Magnum" in 1947.

Erika Stone's career was also influenced by the improvements in flash photography in the 1930s. In place of the awkward flash powder photographers were now able to use flash bulbs that were synchronised with the shutter of the camera that enabled them to take "snapshots" even in poor lighting conditions. As a result flashlight photography penetrated directly into all areas of life and became a motor for a new type of photo-journalism – a speedy and omnipresent visual companion of all of human existence. Erika Stone had her Voigtländer adapted for flash photography and was now able to take on assignments as a photojournalist.

Her first assignments came from the *Riverdale Press*, for whom she worked as a freelancer. She photographed famous inhabitants of Riverdale. More decisive, however, for her own understanding of her photographic work was the contact with the "Photo League" on 21st Street, which Erika Stone joined in 1941. Although the real reason for joining was her search for a new darkroom, the "Photo League" fostered in her a deep and lasting interest in documentary and socially-orientated photography, which found its first clear reflection in her Bowery series.

The "Photo League" was founded shortly before the Great Depression in 1928 as the "Film and Photo League" and was affiliated to the "New School for Social Research".[5] It was originally a primarily politically-motivated organisation, whose aim was to use photography as a radical instrument in uncovering social injustice as part of the political class struggle. After it split off from the "Film League" in 1936 the political agitation diminished considerably, but the preoccupation with photography as a means of socially-orientated documentation not only remained, but was pursued until the

5 Jane Livingston, *The New York School. Photographs 1936-1963*, New York 1992, p. 262ff.

group was dissolved in 1951, by which time it had become their trademark.[6] Group members organised exhibitions, lectures and presentations, gave courses and published their own newspaper, the *Photo News*. The photographic direction they propagated was strongly influenced by Lewis Hine (1874–1940) and Jacob A. Riis (1849–1914). In 1890 Riis, a New York police reporter, had published a sensational book, *How the Other Half Lives*, denouncing the miserable living conditions in the slums of New York's Lower East Side. Between 1906 and 1917 Hine had worked for the "National Child Labor Committee" (NCLC) and had documented child labour in factories and coal mines with his photographs. He left his archive to the "Photo League", whose members were instrumental in ensuring that they were preserved. Many famous photographers were members of the "Photo League" at one time or another: Sid Grossman, Paul Strand, Berenice Abbott, Weegee, W. Eugene Smith, Edward Weston, Ansel Adams, Walter Rosenblum, Helen Levitt, Ruth Orkin, Morris Engel, Dorothea Lange and Lisette Model, as well as the historians of photography Nancy und Beaumont Newhall.

Another of the Photo League's models was Alfred Stieglitz' famous gallery "The Little Galleries of the Photo-Secession" in New York's Fifth Avenue, which was in existence from 1907–1917. It became very well known under the house number 291; not only photographs were exhibited there, but also avant-garde art, including works by Cézanne, Rodin, Picasso, Braque and Picabia. Alfred Stieglitz originally favoured a pictorial style of photography that leant strongly towards painting and attempted to transfer the same principles and themes to the new medium. However, he discarded this type of art photography shortly after the turn of the century. His photograph "The Steerage" (1907) became the incunabulum of a new photographic direction, and its label, "straight photography" became the seal of the movement. The photograph shows a section between the decks of the luxury steamer "Kaiser Wilhelm II.", that opens up onto the passengers travelling third-class. "People, just ordinary people, the atmosphere of the ship, the sky and the sea, and the feeling of relief at getting away from this mob, the so-called rich (…)."[7] Characteristics of this purely direct photography, which also attached particular importance to the formal conception of the photograph, were a renunciation of retouching, the greatest possible definition and an instant recognition of the situation in the image; in short, a photograph should look like a photograph. This photographic movement reflected its subjects and function in a new way and returned to the autonomous laws of the medium of technical images.

The "Photo League" is a part of this tradition, but pushed the social aspect of photography. They put on historical and contemporary exhibitions and devoted numerous exhibitions to single photographers, among them Eugène Atget, Weegee, Lisette Model, Henri Cartier-Bresson, and László Moholy-Nagy. Berenice Abbott

6 The reason for the dissolution was that the "Un-American Activities Committee" during the McCarthy era considered the "Photo League" to be a subversive organisation, i.e. a communist cover organisation, and numerous members were put on its black list. Senator McCarthy pursued a witch-hunt for real and suspected Communists. Many photographers, such as Lisette Model, Margaret Bourke-White, Sid Grossman and Ben Shahn were put under observation, interrogated or obstructed in carrying out their profession. Paul Strand, one of the founding members of the "Photo League" left America as a result and settled in France.

7 Alfred Stieglitz, Wie es zu "The Steerage" kam, in: Winfried Wiegand, *Die Wahrheit der Photographie*, Frankfurt / Main 1981, p. 175.

brought Atget's archive to New York after his death; not only did it inspire the Surrealists in Paris but also found new admirers among the so-called straight photographers.

Apart from the "Photo League", the "New School for Social Research", which the League was originally affiliated to, played a major part in Erika Stone's photographic orientation. It was founded in 1919, modelled on German "Volkshochschulen" (night schools); in the 30s and 40s it could boast a wide range of scientific activity and artistic creativity, above all because the institution was a sort of collecting place for artistic, political and academic refugees from the Nazi regime.[8] There were a large number of courses on photography on offer. Renowned photographers passed on their knowledge in these night classes, among them Alexey Brodovitch (1898–1971), who later became the art director of *Harper's Bazaar*, Joseph Breitenbach (1896–1984), Berenice Abbott (1898–1991) und Lisette Model (1901–1983). Erika Stone studied mostly under Berenice Abbott, who had worked with Man Ray and had given up her own studio in Paris in 1929 to return to the USA. The extensive *Changing New York* (1939) was an impressive portrait of the city in book form. Her intent was to take factual pictures that not only showed the architectonic form, but also the many faces of the city and its inhabitants. "I was able to learn a lot about composing and planning photos from her work,"[9] reminisces Erika Stone about this period of study. The photographer George Tice was later responsible for improving the technical side of her photography. However, Erika Stone also learnt much through the practice of photography, simply by doing her job and improving her control of the practical application of her profession.

New York, the symbol of freedom, boundless expansion, strength, industriousness, the "melting pot" of civilisation, had become the centre of a new type of photojournalism in the 30s and 40s. The city's giant skyscrapers embodied the free world, where everything was possible. It was seen as a bastion against Hitler's fascism. New York delivered a never-ending stream of images of human existence; it was a city renowned for extremes, whether rich or poor; everything was photographable, and the rest of the world stared greedily in admiration at the photographs in magazines and journals. "The Big Apple" provided a good living for the large number of photographers in the city.

One location deserves particular attention in this connection. The Bowery, a street in Manhattan's Lower East Side, was the site of "Sammy's" famous nightclub, which was mostly frequented by New York's demi-monde. A number of photographers were interested in this neighbourhood, the nightclub and its clientel, among them Berenice Abbott, Lisette Model, Weegee and also Erika Stone. Weegee, an Austrian by birth,

8 E.g. Karl Mannheim, Günther Anders, Hanns Eisler, Otto Klemperer, Erwin Piscator.
9 cf. Thomas Honickel, Alltagspoesie, in: *Schwarzweiss* 18, Oktober/November 1998, p. 70.

whose real name was Arthur Fellig, not only left behind a number of photographs but also this fitting description of the nightclub: "At 107 Bowery, sandwiched in between Missions and quarter-a-night flophouses, is 'Sammy's', the poor man's Stork Club. There is no cover charge nor cigarette girl, and a vending machine dispenses cigarettes. Neither is there a hat check girl. Patrons prefer to dance with their hats and coats on. But there is a lively floor show ... the only saloon on the Bowery with a cabaret license. (…) Inside, the place is jammed with the uptown crowd mingling with the Bowery crowd and enjoying it. But towards midnight some odd types drop in for a quick one. There is a woman called 'Pruneface,' a man called 'Horseface,' (and) 'Ethel,' the queen of the Bowery who usually sports a pair of black eyes that nature did not give her."[10]

"Sammy's" was Erika Stone's first published series of photos; she began it in 1946 on the invitation of a Swedish journalist. The characteristics of Erika Stone's photography become particularly clear compared to her colleagues photos of "Sammy's" and the Bowery in the 30s and 40s.

While Abbott concentrates on the architecture of the neighbourhood and the people in the photographs are no more than window-dressing, Model's photographs show a much stronger interest in the individuals. Her photo-series appeared in the September 1947 issue of *Harper's Bazaar* in a collage-like collection put together by Brodovitch. Weegee on the other hand was more concerned with the event, what was going on in the bar. The photographs that he published in his sensational first book *Naked City* (1945) display the sensational and unusual aspects of the subjects, but not the individuals themselves. Erika Stone, the youngest of them all, is closest to Lisette Model in her work, yet at the same time there is a very marked difference. Her photographs are not "snapshots" that capture the protagonists in a more or less unobserved moment, as Model does in her photographs in a masterly way. They are taken with the implicit agreement of the subjects. Even Ethel, the "Queen" of the Bowery, with her plain cigarette and empty glass in her right hand, knows that she is being photographed. With her head resting on her left hand, she stares into the distance with a care-worn expression (ill. p. 41).

A major characteristic that runs through all of Stone's photography is apparent here: even in her "snapshots", when the subjects are unaware that they are being watched, the observer has the impression that the dignity of the person has been preserved, no matter whether they are famous or unknown, rich or poor. The camera does not ridicule the subjects or expose them. Stones photographs awake in us a certain nearness to the subject and the feeling of having been there ouselves. It is not obtrusive photography, Erika Stone approaches her subject with care. Even her photographs of human misery are not intended to shock, rather they are an appeal

10 Weegee, *Naked City*, New York 1945, p. 138.

to the sympathy of the viewer. Her photographs are deliberately moving. The photographs of black Harlem dating from the 40s – they were part of a project in co-operation with the "Photo League" to document the different neighbourhoods in Manhatten – show scenes of everyday life, a flower-seller, a day-laborer asleep, an old man and child, but the surroundings, and above all the faces, betray on closer inspection the worries of daily existence.

A year after the publication of the Bowery series in the Swedish newspaper *Vecko-Journalen* Erika Stone went to Tanglewood in Lenox, Massachusetts. Her passion for classical music was one of the reasons for her observing personalities from the music world at the "Tanglewood Music Center", which had been founded in 1940. However, her financial situation was so precarious that she had to work as a waitress in nearby Pittsfield in the evenings after she had attended the rehearsals and watched the musicians during the day. "In those days all the well-known musicians had lunch outside on the lawn with the students. It was such a different atmosphere. I'd spend every day there and I met all the big names – Leonard Bernstein (whom everyone just called Lenny), Copeland, Foss, Koussevitzky – and at about 3.30 in the afternoon I would mysteriously disappear, hitch a ride to Howard Johnson's and become a waitress!"[11] Impressive photographs date from this time, for example "Lenny" during rehearsals or in conversation with his students. Erika Stone succeeded in capturing the relaxed atmosphere of these classical music sessions in her photographs (ill. p. 62). Tanglewood remained a favourite location for Erika Stone for many years. *Life* magazine published her photo of Serge Koussevitzky's 50th birthday, the founder of the Tanglewood Festival. In 1961 Stone photographed the actor Danny Kaye on stage directing the Berkshire Symphony Orchestra and behind the stage with the Charles Muench (ill. p. 58). She also observed the music students before and after rehearsals with her camera.

In 1952 Erika Stone decided to visit the famous "Casals Music Festival" in Prades in the south of France. Isaac Stern and his German wife Vera introduced her to Pablo Casals, who agreed to give concerts again only in 1950, the 200th anniversary of Johann Sebastian Bach's death, and thus founded this magnificent festival. Sensitive portraits of the great cellist, composer and conductor date from this time. She also photographed him again in 1956 at the "Malborough Music Festival" in Vermont (ill. p. 63). Stone also took an expressive and unusual photograph of the English pianist Dame Myra Hess (1890–1965), who had given a critically-acclaimed Brahms' concert under Koussevitzky in Boston in 1938 and appeared at the Casals Festival in 1952 (ill. p. 64). Myra Hess sits at the piano with a lighted cigarette in her mouth, a woman whose piano-playing was imbued with virtuosity and poetic sensitivity.[12] Stone remembers her work at these

11 cf. *The Country*, Vol.2, Issue 4, Sep. 1997, p. 23.
12 During World War II she organised numerous so-called "lunch-time" concerts in the National Gallery in London. She was made a "Dame of the British Empire" in 1941.

festival thus: "Mostly I worked during the rehearsals. I'm not a person that is aggressive, I'm rather shy and unobtrusive, and I try to catch people during a particular moment."[13] To capture with the camera a particular moment or as Cartier-Bresson put it, the "decisive moment"[14], has remained a central aim for Erika Stone up to this day. Lisette Model enlarged details from her negatives, distancing herself from Cartier-Bresson's purist attitude, according to which the only binding detail is that which the camera itself has found; Stone also chose when necessary to crop the negative in the darkroom: "I did a lot of 'cropping' with my pictures and seldom used the entire negative."

From 1947 to 1953 Erika Stone worked for the "European Picture Service", an international photo agency, where she not only took on assignments but also handled captions, translations and sales. She finally succeeded in selling her photoreportages worldwide via this agency. In 1951 she was one of the winners of the *Life Magazine* contest for young photographers. Her photostory was catchy, easy to understand and funny. Her theme was a shoe-shine machine. In a series of eight photographs she showed the acrobatic contortions the users of this "pioneering" machine had to perform – incredible gymnastic movements and skipping – in order to clean their shoes properly. The images follow one another, almost in a cinematographic sequence, reminiscent of the combination of steps in one's first dancing lesson, where one still practices without a partner. Erika Stone also provided comments on each photo in couplet form. The impressive thing about these photos is the way in which the camera captures the men's acrobatic contortions slightly from below. Zooming in with the camera from this position endows the subjects with monumental proportions, so that each clumsy movement becomes an exemplary action. Her finely-honed irony also caricatures the unshakeable belief of her contemporaries in the infallibility of technology; the machine as a symbol of progress and prosperity, even if it is only a shoe-shine machine whose use is likely to make the customer a laughing stock and take up more of his time than otherwise. The other prize-winners were Dennis Stock, whose political reportage covered the arrival of refugees from East Germany, and Elliott Erwitt.

Following the restrictions of World War II photojournalism enjoyed a boom in the 50s. Diverse magazines, journals and newspapers such as *Life, Harper's Bazaar, Venture, Paris Match, Vogue, Vu, Look,* and *Spiegel* offered a wide range of themes for photographers. There was a huge demand for photoreportage of all kinds, whether political, entertaining, damning or frivolous. A new internationalism spread and people were interested in what was going on in the world, whether it was gossip, politics or art. Yet in spite of this international disposition the print media focussed mainly on the western world, whose progress and new luxuries were displayed like trophies. The rapid

13 cf. *The Paper*, 6 Aug. 1992, p. 5.
14 Henri Cartier-Bresson, *The Decisive Moment*, New York 1952. Cf. Colin Westerbeck, Joel Meyerowitz,
 Bystander: A History of Street Photography, Boston 1994, *The Decisive Photographer*, p. 153ff.

developments in camera technology also played a part. Newer and lighter small-format cameras with built-in rangefinders were quick and easy to use and made photographers extremely mobile.[15] It was only towards the end of the 20th century that the demand for photographic images suffered a serious crisis that almost toppled the old world of pictures: the so-called new media provided even quicker access to the world and simultaneously delivered moving pictures to every household. In 1996 the magazine *American Photo* posed the question: "Is photojournalism dead?"[16] and a year later this question provided the theme for an exhibition.[17]

Up to the 80s the demand for photographic images remained unbroken and Erika Stone, like many of her colleagues, was able to work for numerous magazines such as *Time*, *This Week Magazine*, *The Sunday News* or *Spiegel*. In 1953 Stone had decided along with her friend Anita Beer, to found her own photo agency, "Photo Representatives", which was in existence until 1959. She could now decide how to distribute her photos herself and was no longer dependent on the interest or disposition of other agencies. The agency also had some prominent colleagues on its books, such as Weegee and Horace Bristol. The decisive factor in giving up the agency in 1959 was not economic – on the contrary, it had become well-established despite strong competition – rather it was Stone's family situation. In 1954 she had married the writer William Stone and four years later her son Michael was born, followed by David in 1960. Not only was continuous working almost impossible, but equally decisive for the decision to give up the agency was that Erika Stone deliberately chose to devote herself and her time to her children. She retired from the photography business and restricted herself at first to capturing the "decisive moments" in her own family life on film. However, these private experiences were to have a strong influence on her future photojournalistic ambitions.

But let us return first to the photographs that Erika Stone took at the peak of photojournalistic photography. Alfred Eisenstaedt (1898–1995), who like Stone had emigrated to the USA in 1936 and who delivered over 90 cover photos for *Life*, was one of the pioneers and staunch representatives of so-called "Available Light"-photography. He deliberately rejected flashlight very early on and used only the available light to capture the prevailing atmosphere. Henri Cartier-Bresson used similar arguments in 1952 when talking about the practice of photojournalism: "No flashlights, of course, even if it is only out of respect for the most meagre natural light. Otherwise the photographer becomes an unbearably aggressive being."[18] This attitude had a strong influence on Erika Stone, who also rejected flash photography in the 50s – her photos in "Sammy's Bar" all used flashlight – for the available light, which was much more in keeping with her conception of unobtrusive and respectful photography.

15 Leitz introduced the first cameras with built-in rangefinder and interchangeable lense in 1932. The Leicas, small 35mm cameras, became the standard equipment of many photojournalists.

16 *American Photo*, September/Oktober 1996.

17 Urs Stahel and Martin Gasser (ed.), *Weltenblicke – Reportagefotografie und ihre Medien*. Exhibition catalogue Fotomuseum Winterthur, Winterthur 1997.

18 cf. Walter Kemp, *Theorie der Photographie*, Vol. II, 1912-1945, München 1979, p. 83.

In 1951 Stone took a close-up photograph of a nun standing among a group of people outdoors in New York City. The subject of the photograph also has a camera in her hands and the photographer Erika Stone in her viewfinder (ill. p. 53). This portrait is very revealing about how Stone views her role in her contact with her subjects and about her understanding of the medium itself. One might think at first sight that the photo is a sort of snapshot. Stone saw the nun busy with her camera and was fascinated by the unusual internal tension of the image: a woman in holy orders, probably rather sceptical of the modern world, interesting herself with technology in order to make technical pictures. At a second glance, however, we can see that Stone's photo was taken with the subject's conscious agreement. The nun knows that she is being photographed and focusses for her part, with a gentle smile on her lips, on the photographer, who we cannot see but whose head throws a weak shadow on the nun's habit. The nun is using a very popular camera, Kodak's Brownie Reflex Syncro, which resembles a twin-lens reflex camera, but with a brilliant viewfinder and focussing hood; the first version was brought onto the market by George Eastman in 1900 and particularly appealed to amateur photographers. The nun looks into the camera from above, a typical pose that earned the derisory epithet "navel perspective" towards the end of the 20s from Alexander Rodtschenko, a co-founder of the "New Perspective" in photography.[19] Seen in purely formal terms, the chosen composition is impressive. The sweeping white line of the nun's hood cuts her off from the rest of the world and creates a special intimacy between her and the observer.

Erika Stone also photographed numerous showbiz stars. She took an unusual shot of Ginger Rogers (1911–1995), best known as Fred Astaire's partner in countless song and dance films, at the tennis championships in Forest Hills. Dressed in tennis whites and standing in the glaring sun, she playfully holds her tennis racket in front of her face to shield her from the sun. The strings of the racket throw a net-like shadow onto her face, giving the impression of a hat and veil (ill. p. 65). Lauren Bacall and Clark Gable on the other hand were photographed at one of Eisenhower's election parties. Eisenhowever was the Republican Presidential Candidate and had won the actress Bacall as a prominent supporter, although she herself was a declared Democrat (ill. p. 56 and 60).

In March 1955 the famous Ringling Brothers and Barnum & Bailey Circus appeared in New York's Madison Square Garden. On March 30th Erika Stone waited along with 200 other photographers for the main event of this charity performance, the appearance of Marilyn Monroe and Marlene Dietrich. Marilyn appeared riding a pink elephant, while Marlene took the stage in a circus director's costume. Ed Feingersh and Walter Carone were also among the crowd of photographers. Particularly when compared with

19 A. M. Rodtschenko. *Aufsätze, Autobiographische Notizen, Briefe, Erinnerungen*. Dresden 1993, p. 154.

Carone's photo for *Paris Match*, Stone's photograph shows a completely different view of the star. Carone shows Marilyn Monroe virtually from the front and monumentally in the centre of the photo, seen from below, looking into her low-cut dress, a sensual incarnation of female erotic aura.[20] Marilyn had made such an deep impression on Carone that he was as "shy as a schoolboy" in her presence.[21] His photo doesn't reveal that he was only one of many photographing Marilyn, whereas Stone uses another photographer in her composition, creating distance between her and the object of male desires. She shows Monroe from the side and at a greater distance, more in rapture as a smiling Glamour Girl than as the sex symbol par excellence (ill. p. 59). Marlene Dietrich (ill. p. 55) on the other hand obviously posed for Stone's portrait. We see her slightly from below and just out of focus; the spotlight from the side and the quiet, almost frozen smile give the photograph a melancholy atmosphere reminiscent of the famous portrait of Dietrich taken by Alfred Eisenstaedt in 1928.[22]

Photographs of stars and famous people take up only a relatively small part in the wide spectrum of Erika Stone's photography. She is more interested in so-called "ordinary people". "Of course it is interesting to take photographs of such famous people, but my favourite motives are normal, everyday people. People in tense situations or expressing joy, mourning, alienation, proximity, humour."[23] Erika Stone has kept to the path of documentary and socially-orientated photography, as propagated by the "Photo League" all of her life; however, as we will see, her main emphasis has changed over the years.

Erika Stone also photographed Ellis Island, the small island in New York harbour in the shadow of the Statue of Liberty, where between 1892 and 1954 12 million immigrants had to wait for their immigration papers to the New World. One of her photos of 1951 is of "The Great Hall", where the imigrants were registered and given medical examinations. When viewing the photographs, in which a couple and child keep recurring, one could easily imagine that Stone is reflecting on her own family history and past (ill. p. 46, 47).

In 1955 Edward Steichen (1879–1973), co-founder of the "Photo-Secession" and since 1946 curator of the newly-created photography collection of the Museum of Modern Art, organised the influential international exhibition "The Family of Man". It took three years of preparation to select 503 photographs from over two million photographs submitted by famous and less well-known photographers from 68 different countries. The exhibition went on a Grand Tour, starting in the Museum of Modern Art and ending, via Paris and other cities, in Moscow. Ten million people saw the exhibition. Although Erika Stone didn't submit any photographs for this exhibition, her aims can be compared with the ideals of this world-spanning exhibition that was to

20 Serge Bramly, *Walter Carone Photographe*, Munich 1992, plate 88.
21 ibid. p. 24.
22 Alfred Eisenstaedt, *People*, Westford 1979, p. 25.
23 Ellen Küppers, "Erika Stone: Photographin für Life", in: *Aufbau* 1993 (12 Feb. 1993), p. 24.

mark the climax of "humanist photographic reportage". As Steichen emphasised in his introduction, he saw photography "as a mirror of the universal elements and emotions in the everydayness of life – as a mirror of the essential oneness mankind throughout the world."[24] He appealed to the elements that bind peoples together, the human ethic, beyond territorial, political or social boundaries. In 1947, shortly after the end of World War II, the French culture historian and later Minister of Culture, André Malraux, had published his *Musée Imaginaire*, in which he created a universal history of art in the form of an artbook and thus proclaimed a sort of world art. He wanted to discover creative man in the universe of his pictures, free of any historical or contextual references. For Steichen and Malraux the new Universalism was causally related to the horrors of the war, particularly the National Socialists' organised machinery of extermination, which rocked the very foundations of human civilisation. Photography had achieved a new certainty from its consistent accompaniment of the war and could even be called as a witness as the photographs of Lee Miller and Margaret Bourke-White proved. Edward Steichen's exhibition of human photography aimed at international understanding can also be seen in this context – an attempt to bring back to life the common human experience that had long been thought dead.[25]

Erika Stone pursued her documentary and socially-orientated photography after the birth of her two sons, but the main emphasis of her work had shifted. She accompanied their childhood with the camera. Similar to her photographic beginnings in the late 30s, she gradually expanded this activity until she finally specialised in photographing children, which she did with a deep conviction. "I feel that we must do something to see that all children can have secure childhoods."[26] The necessary sensitivity came on the one hand from her own childhood experiences; on the other hand she had become aware of the tremendous importance of a secure childhood through her activities as a photojournalist up to that point. In 1977 she took part in the 4th World Photography Exhibition "The Child", supported by UNICEF. In 1981 Stone came into direct contact with the international organisation "SOS Kinderdorf", when she was given the assignment by *Parents' Magazine* to do a photostory on the institution that had been founded by Hermann Gmeiner in 1949. Apart from various photoseries for family magazines, Erikas Stone also published numerous children's books as well as a popular manual on photographing children: *Pro-Techniques of Photographing Children*.

Erika Stone photographed children with the same care and understanding that she had earlier shown with her expressive portraits from the adult world. They are not sentimental or tear-jerking photographs. The dignity of the children is at the centre of these passionate photographs.

24 Edward Steichen, introduction to *The Family of Man*, New York 1955.
25 World War II had also shown that photography could equally be misused for propaganda purposes, and was therefore dependent on the interests it served.
26 cf. *The Paper*, 6 Aug. 1992, p. 7.

Erika Stone's eagerness to travel, which had taken her on excursions to Morocco, Israel, China and India, was interrupted for a short time in 1987 when she was the victim of a mugging in New York and seriously injured. Her will to live and her passion for a committed photography remained unbroken, however. She soon undertook longer trips again; in 1989, for example, she went on a photographic tour of Scandinavia and Russia.

Erika Stone's photography concentrates primarily on people, people in an urban environment. Purely architectural or landscape photographs are the exception, although they show her feeling for composition, lighting and detail just as much as the portraits. She also used colour material for the photographs of children, but for the primarily documentary-orientated photography she prefered black and white. The extent to which photography has defined Stone's life and to what extent man as a socially-defined being is at the centre of her photography is made clear in this final quotation from Erika Stone:

"Photography has indeed filled my life. It has filled it with endless visual excitement as well as the challenge and satisfaction of getting moments which have tickled my vision on film. Many subjects inspire me but none as much as capturing a special second in the life of man, woman or child. People are my favorite subjects and I continue to marvel at the diversity and uniqueness of each individual. They, to me, give life its fullness, its richness. Their sorrows fill me with compassion and their joys move me deeply. To me, people are what the world is all about. That is why my camera will always seek them out."

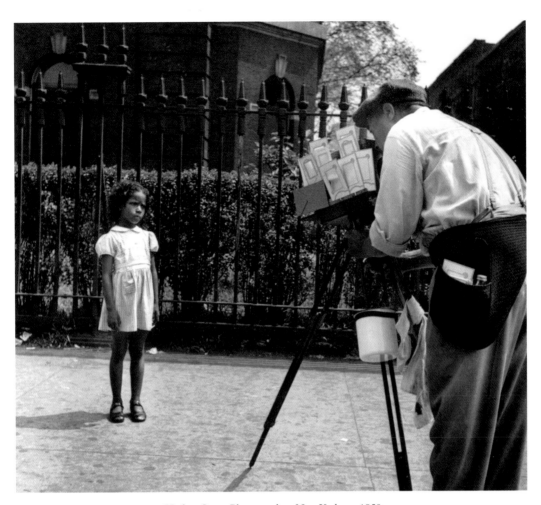

Harlem Street Photographer, New York, ca. 1950

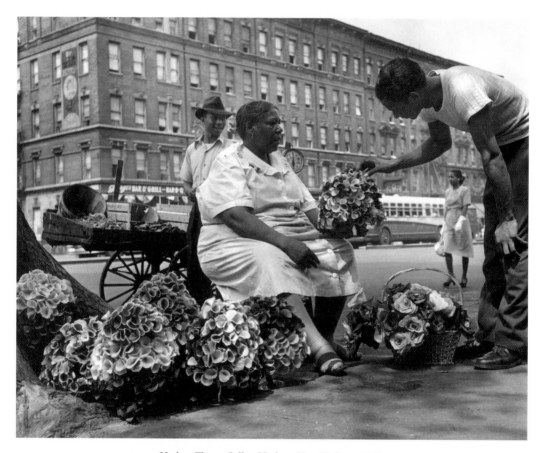

Harlem Flower Seller, Harlem, New York, ca. 1940

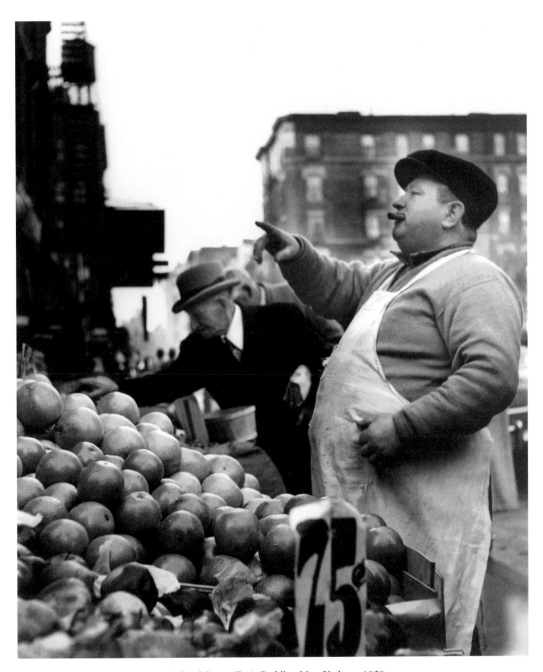

Orchard Street, Fruit Peddler, New York, ca. 1950

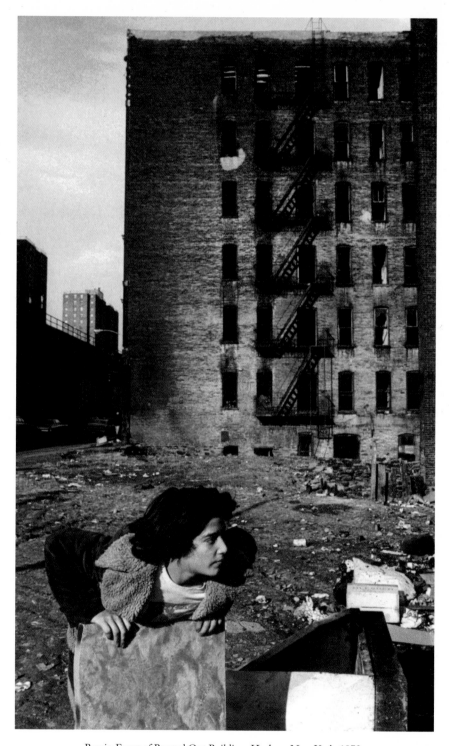

Boy in Front of Burned Out Building, Harlem, New York, 1972

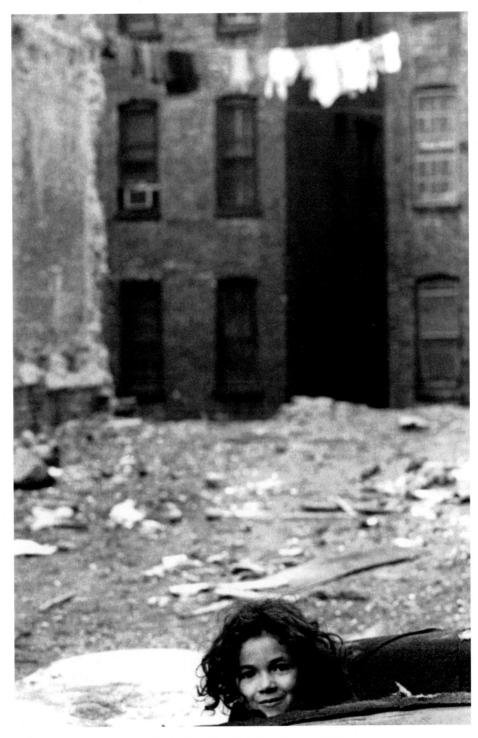

Child in Lot, New York, East Harlem, 1965

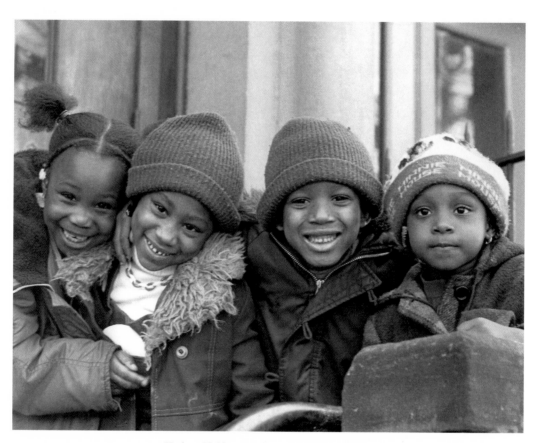

Harlem Children, Harlem, New York, ca. 1970

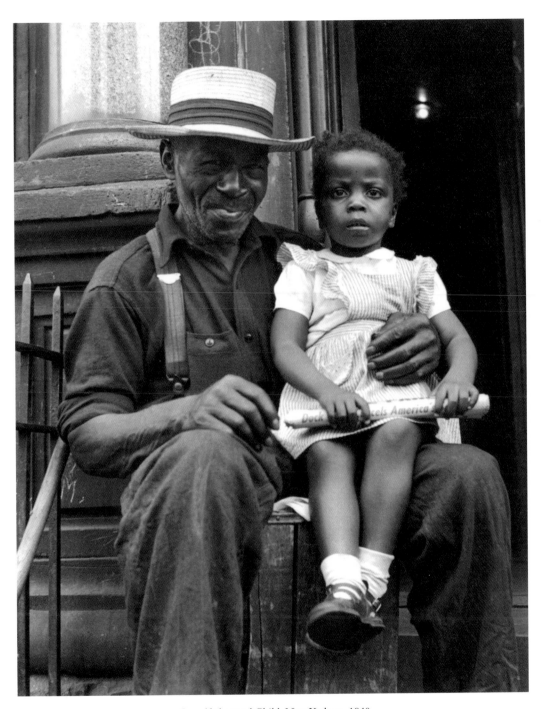

Grandfather and Child, New York, ca. 1940

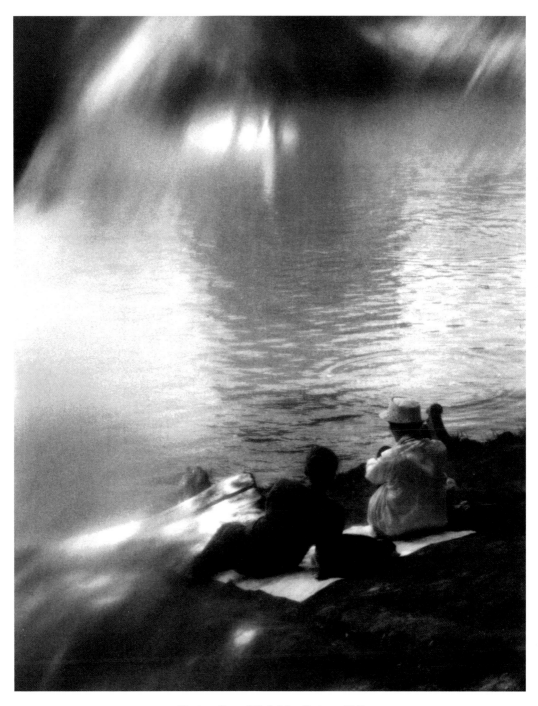

Picnic at Central Park, New York, ca. 1960

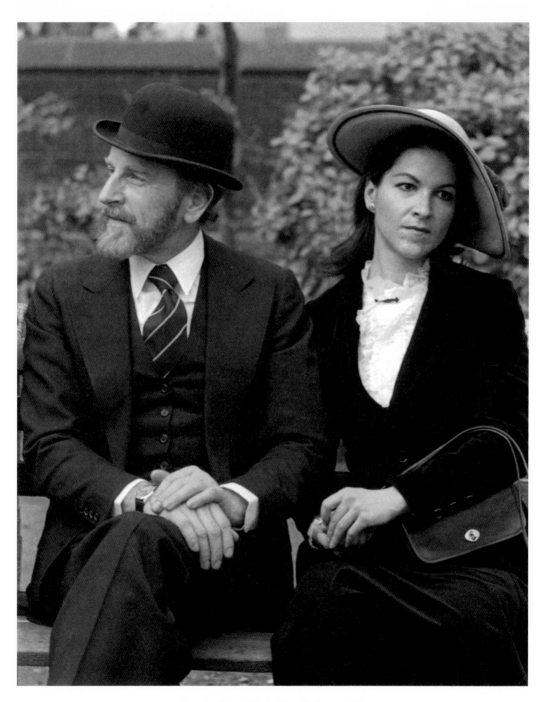

Couple, Central Park, New York, ca. 1970

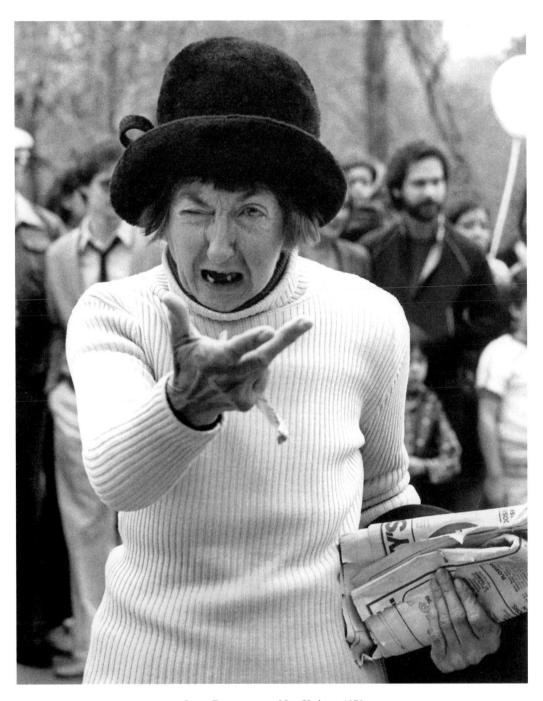

Street Demonstrator, New York, ca. 1970

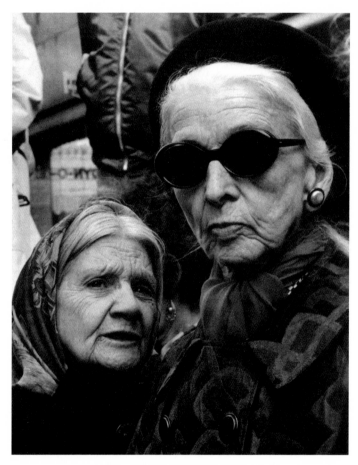

Two Oldies, New York, ca. 1960

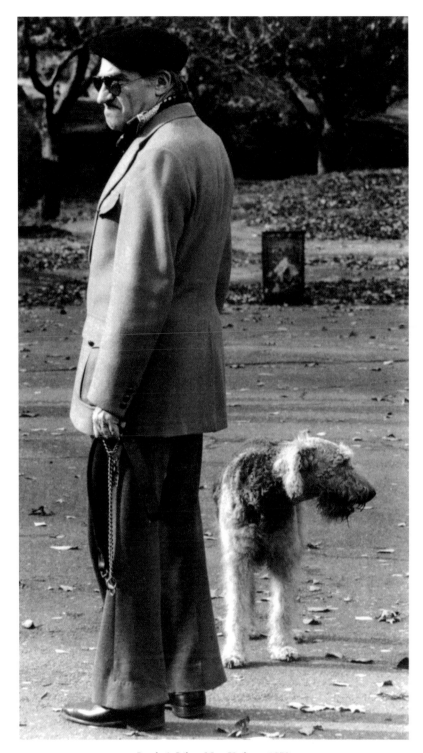

Look-A-Likes, New York, ca. 1970

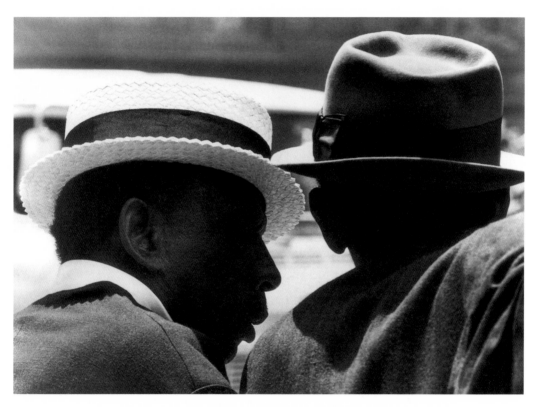

Hats, Harlem, New York, ca. 1970

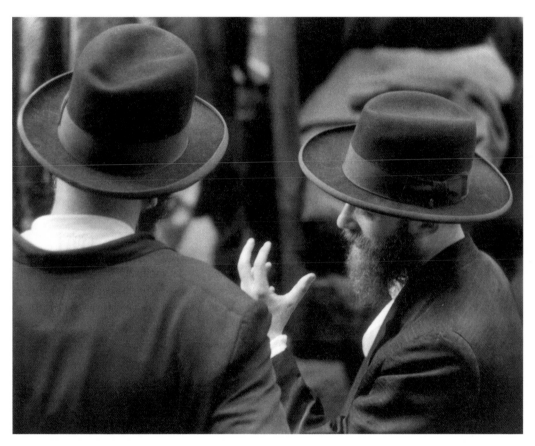

47th Street, New York, ca. 1970

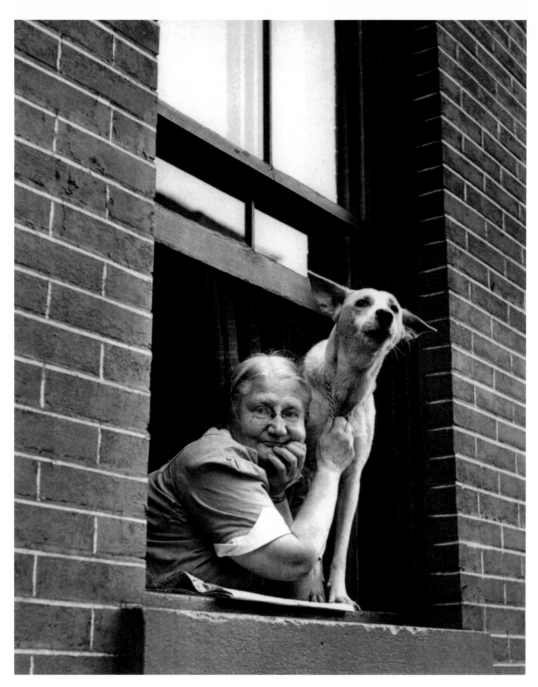

Pair in Window, New York, ca. 1950

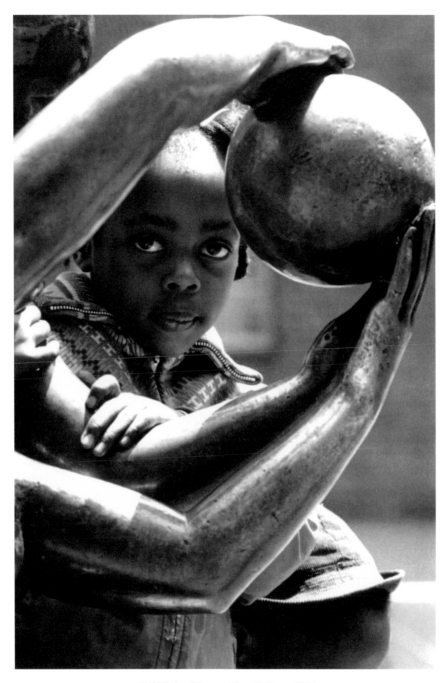

Child Behind Statue, New York, ca. 1960

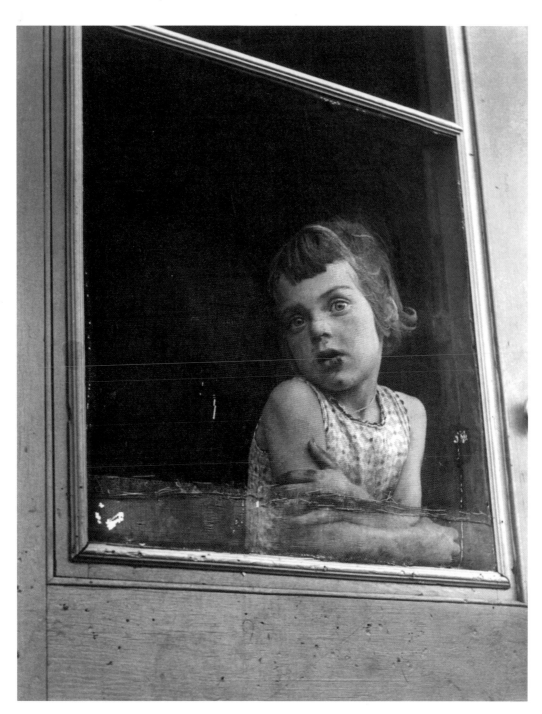

Child Behind Screen Door, Canada, 1956

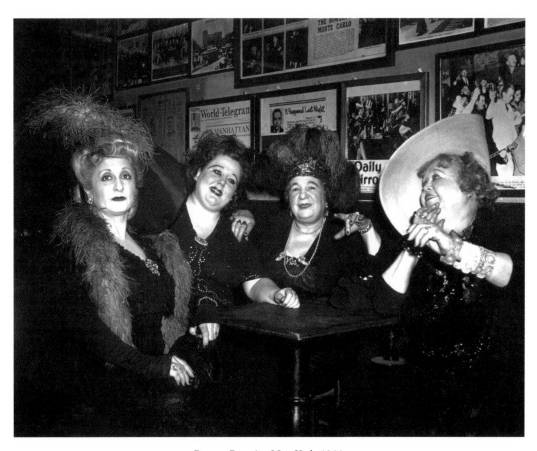

Bowery Beauties, New York, 1946

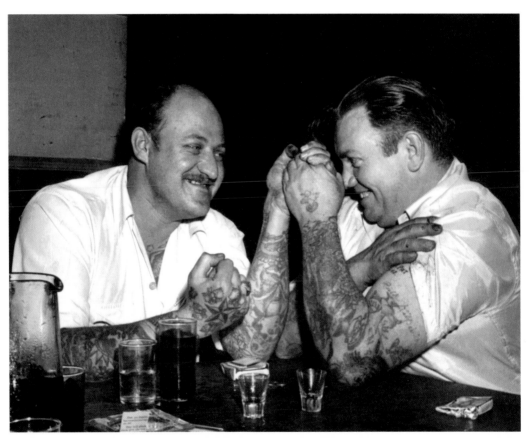

Test of Strength, Sammy's Bar, New York, 1946

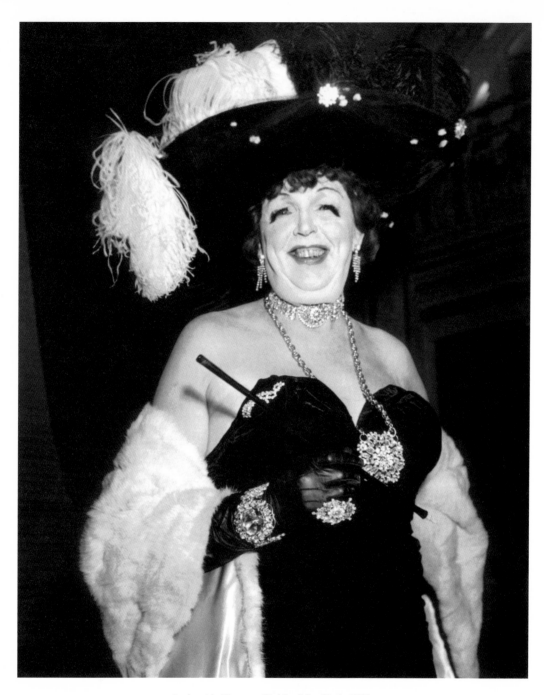

Lady with Cigarette Holder, New York, 1953

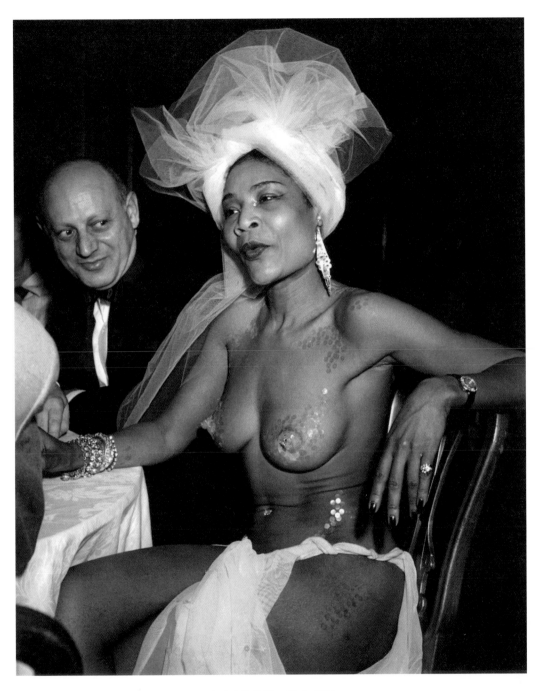

Artist's Ball, New York, 1953

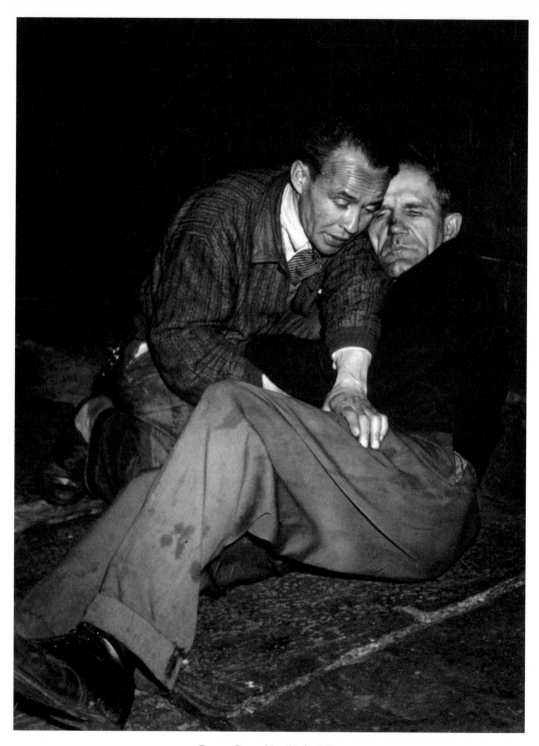

Bowery Bums, New York, 1942

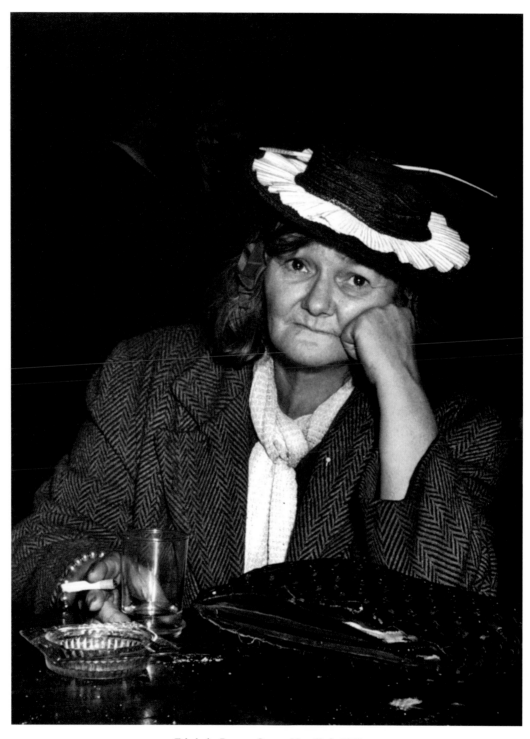

Ethel, the Bowery Queen, New York, 1946

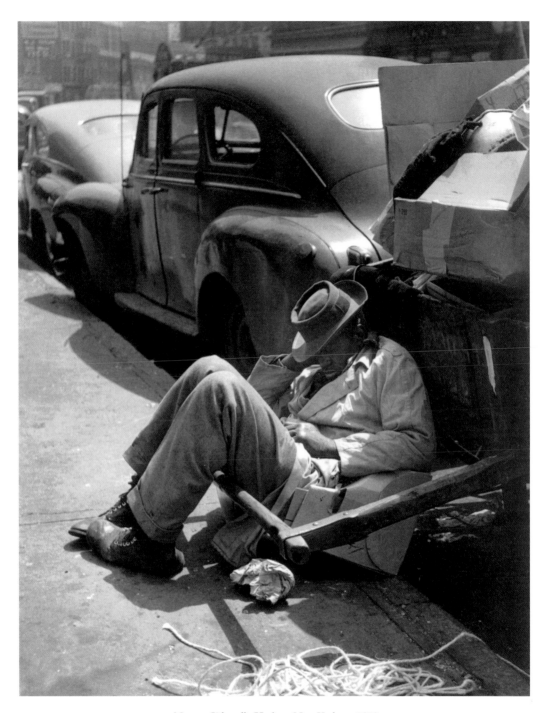

Man on Sidewalk, Harlem, New York, ca. 1940

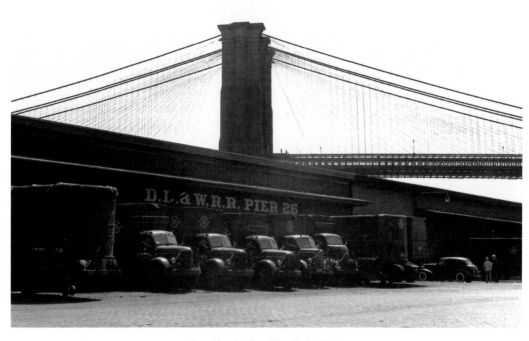

Brooklyn Bridge, New York, 1949

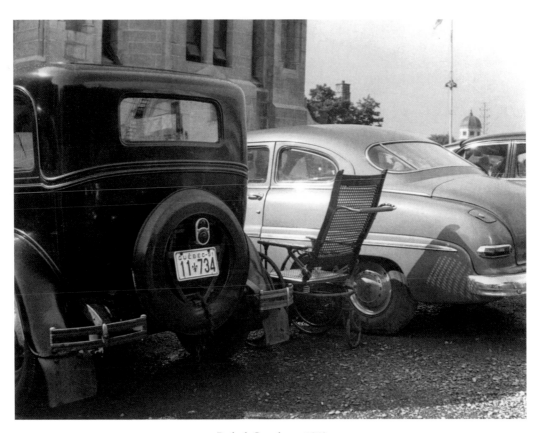

Parked, Canada, ca. 1940

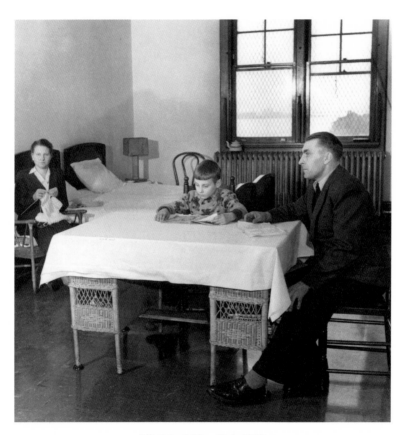

Ellis Island, New York, 1951

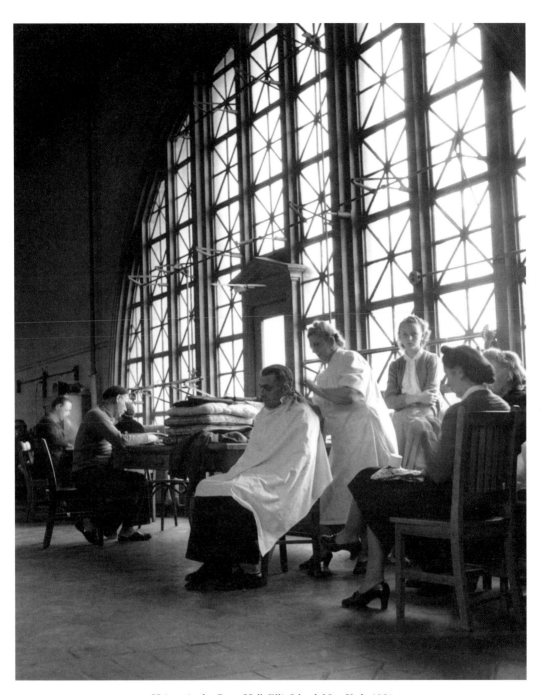

Haircut in the Great Hall, Ellis Island, New York, 1951

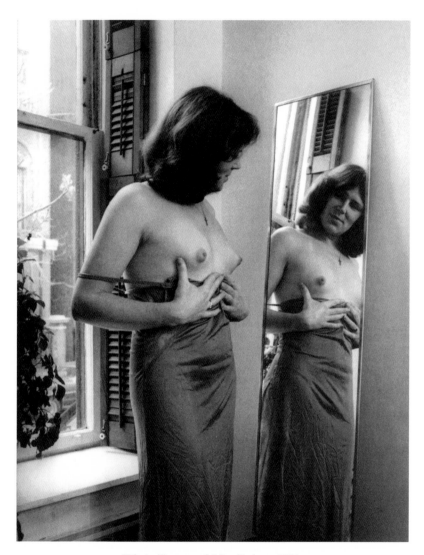

Valerie, Transsexual, New York, ca. 1970

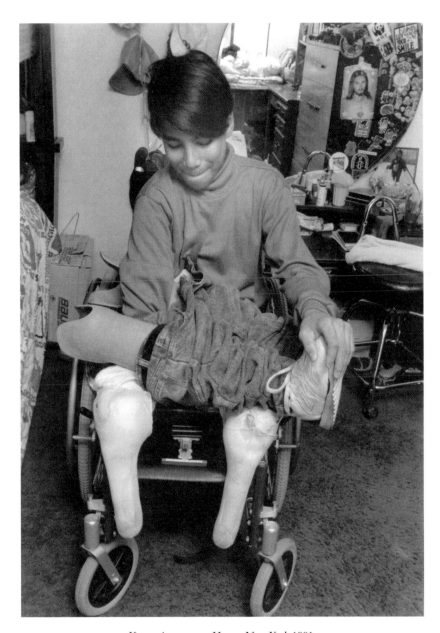

Young Amputee at Home, New York 1991

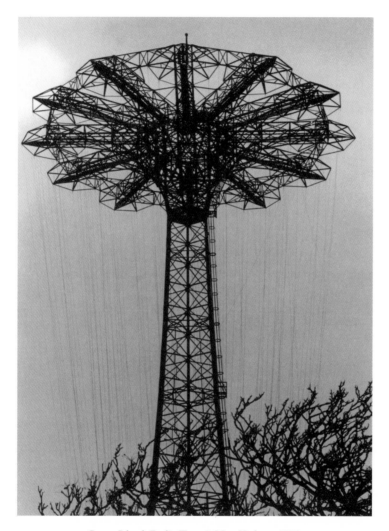

Coney Island (Radio Tower), New York, ca. 1970

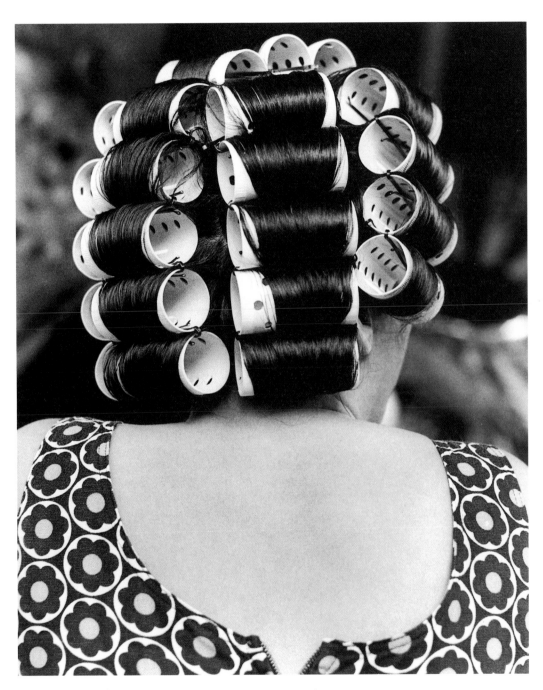

Lady with Curlers, New York, ca. 1970

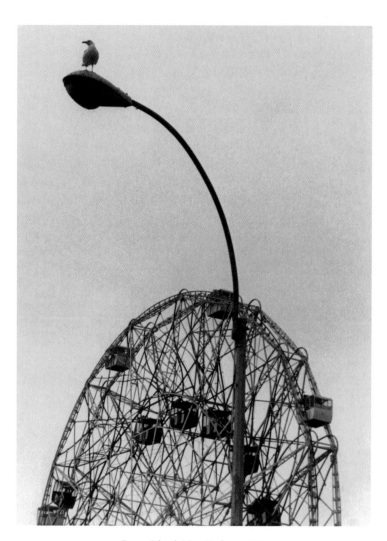

Coney Island, New York, ca. 1970

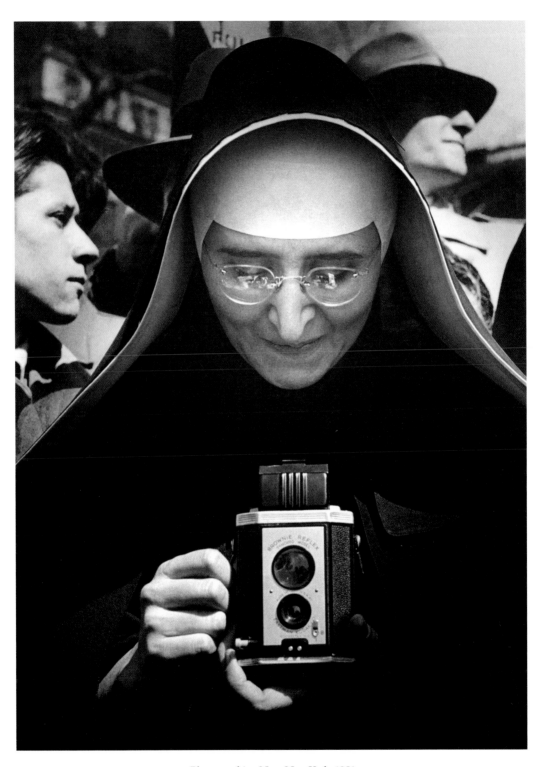

Photographing Nun, New York, 1951

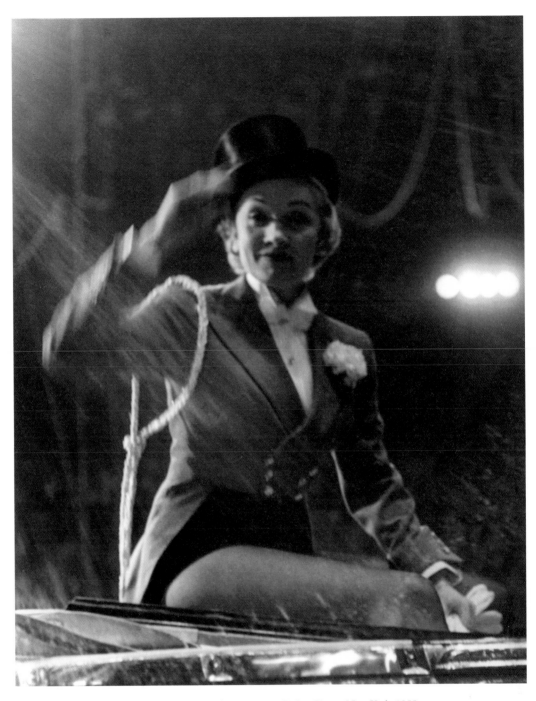

Marlene Dietrich at the Barnum & Bailey Circus, New York, 1955

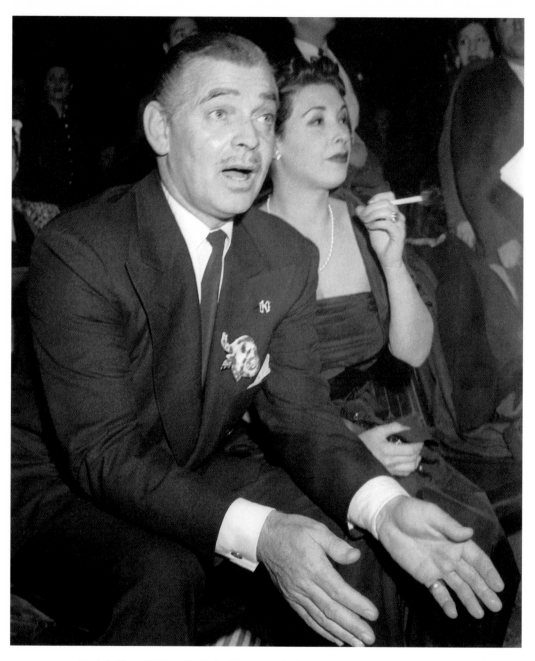

Clark Gable and Wife at Ike Rally (Eisenhower's Election Campaign), New York, 1952

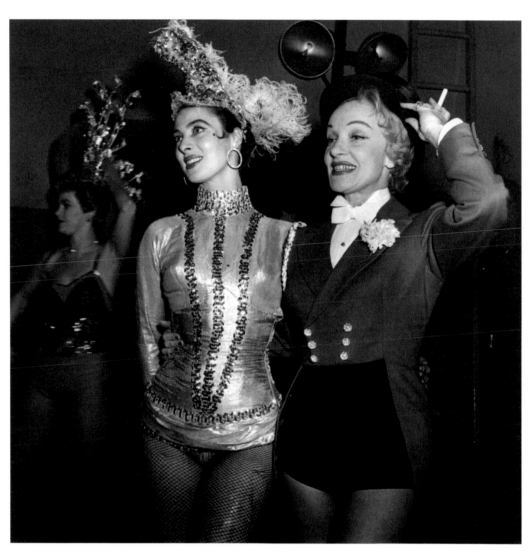

Marlene Dietrich and Rita Gam at the Barnum & Bailey Circus,
New York, 1955

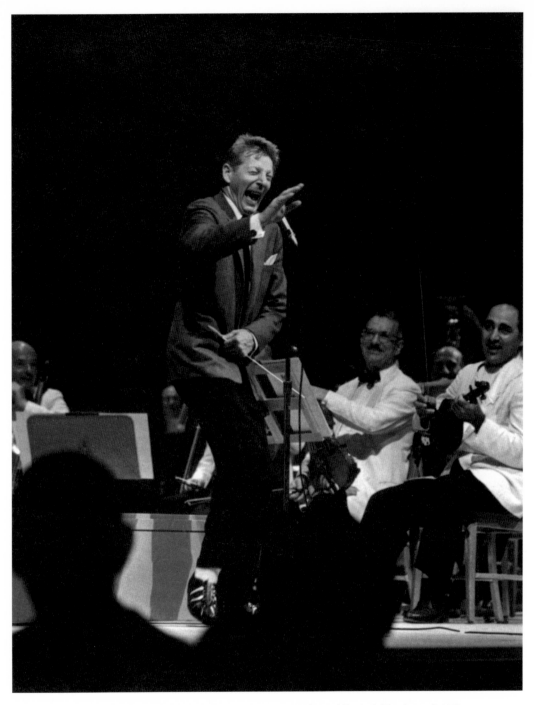

Danny Kaye (1913–1987, comedian and actor) at Tanglewood Festival, Tanglewood, 1961

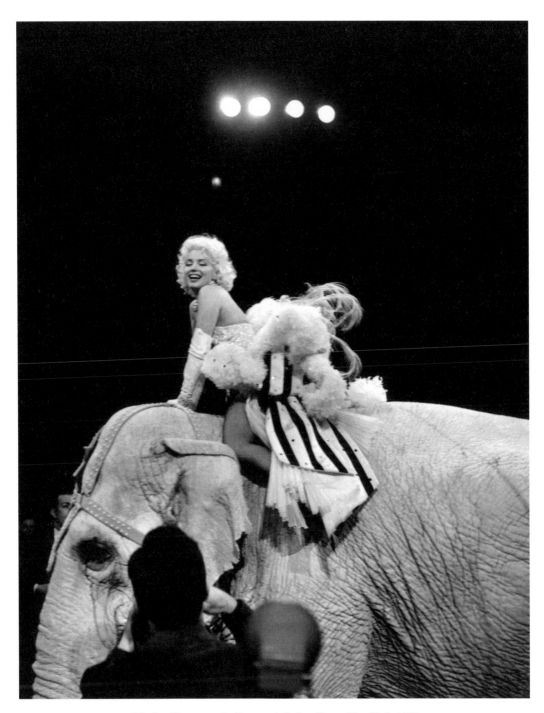

Marilyn Monroe at the Barnum & Bailey Circus, New York, 1955

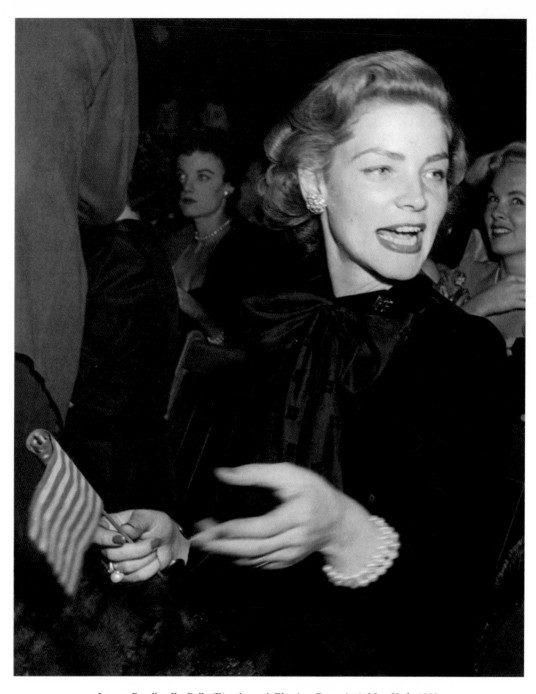

Lauren Bacall at Ike Rally (Eisenhower's Election Campaign), New York, 1952

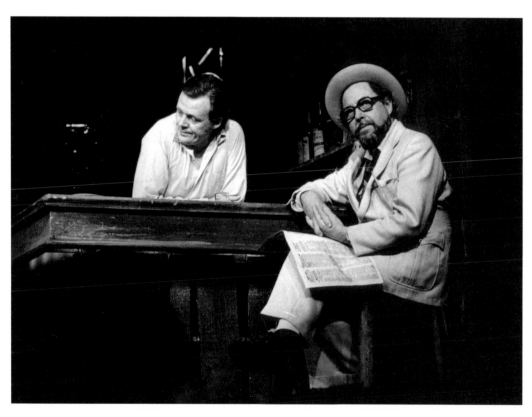

Tennessee Williams in *Small Craft Warnings*, New York, 1972

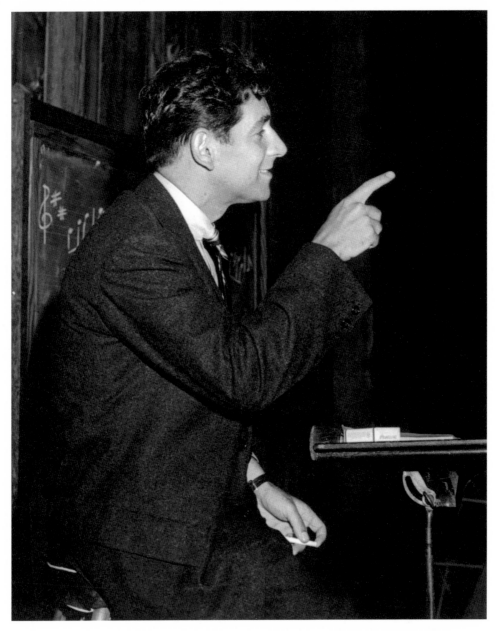

Leonard Bernstein (1918–1990, conductor, composer and pianist) at Tanglewood Festival,
Tanglewood, 1947

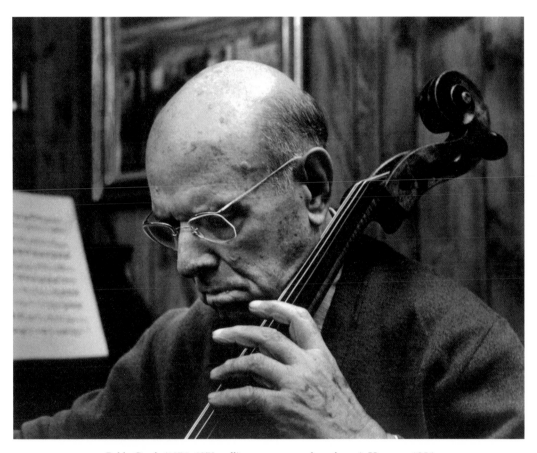

Pablo Casals (1876–1973, cellist, composer and conductor), Vermont, 1956

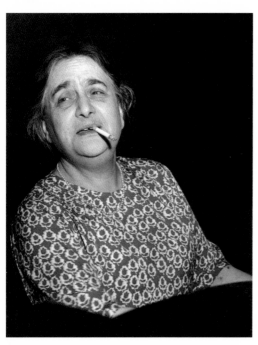

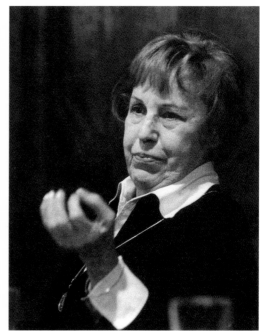

Dame Myra Hess (1890–1965, pianist)
at the Casals Music Festival, Prades, France, 1952

Lotte Lenya (1898–1981, actress and singer),
ca. 1980

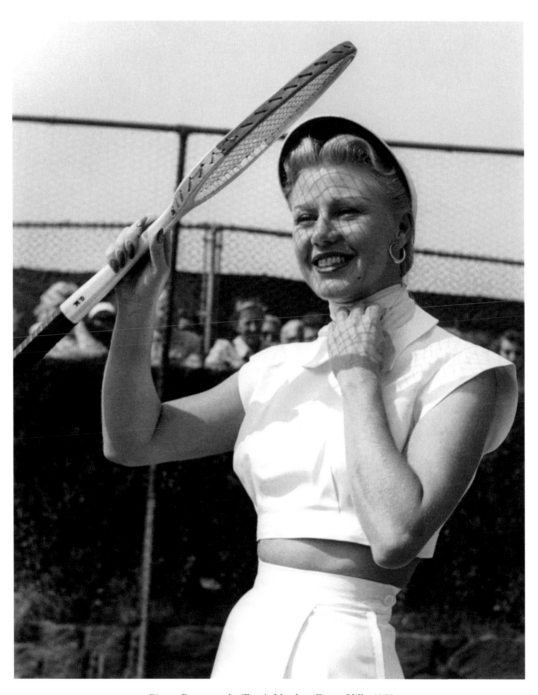

Ginger Rogers at the Tennis Matches, Forest Hills, 1950

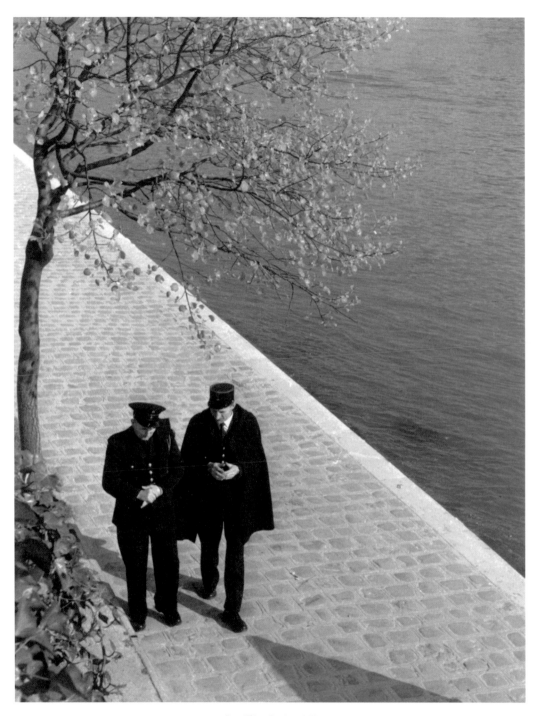

Les Flics, Paris, 1952

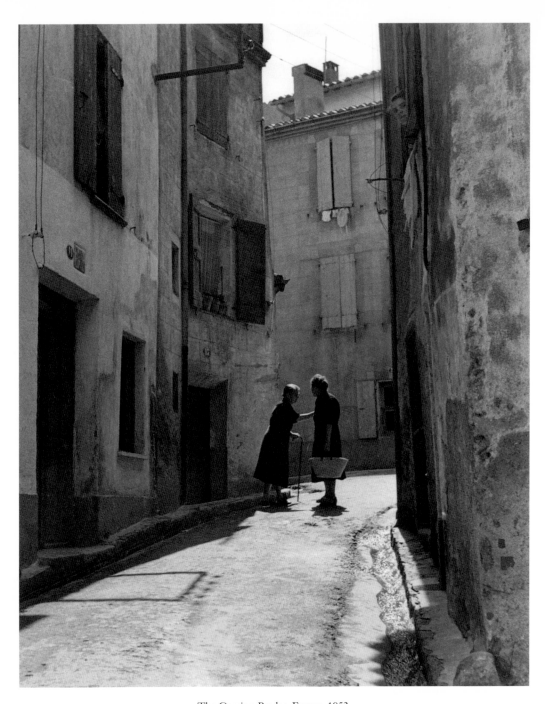

The Gossips, Prades, France, 1952

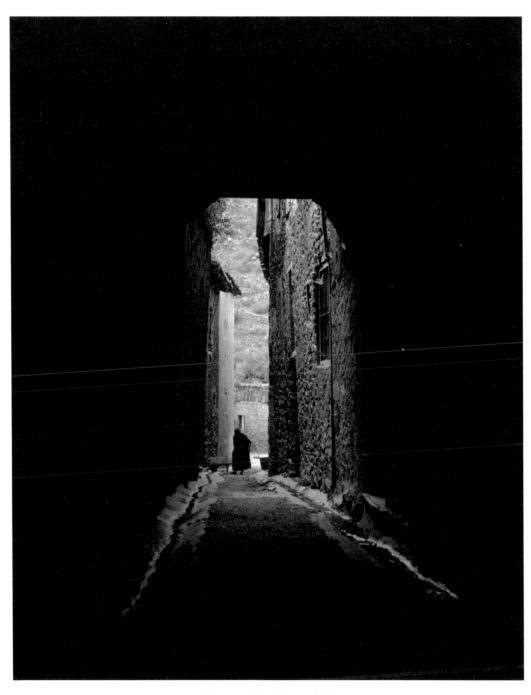

Pyreneean Alley, France, 1952

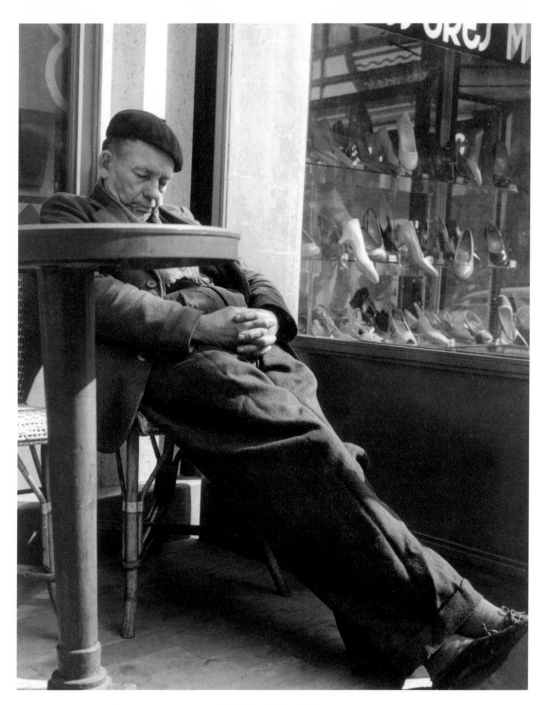

The Nap, Paris, 1957

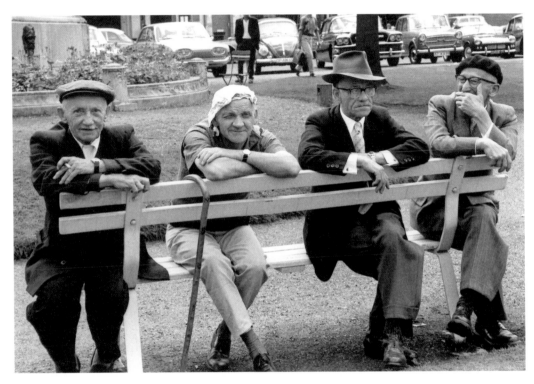

Four on a Bench, France, 1952

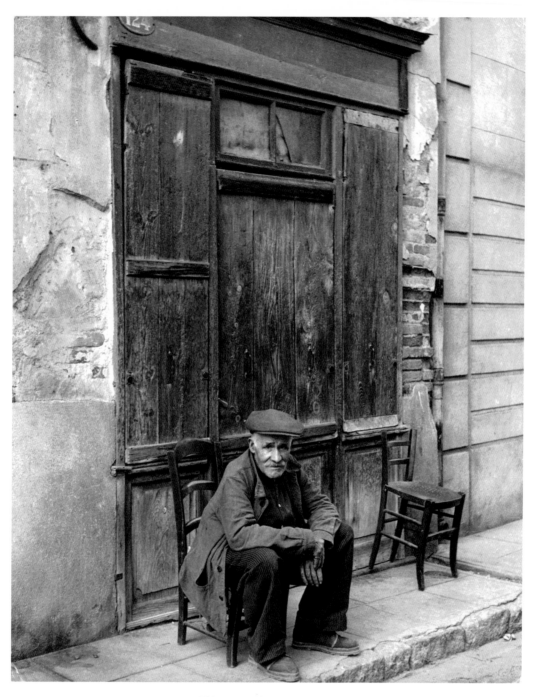

Old Man, Prades, France, 1952

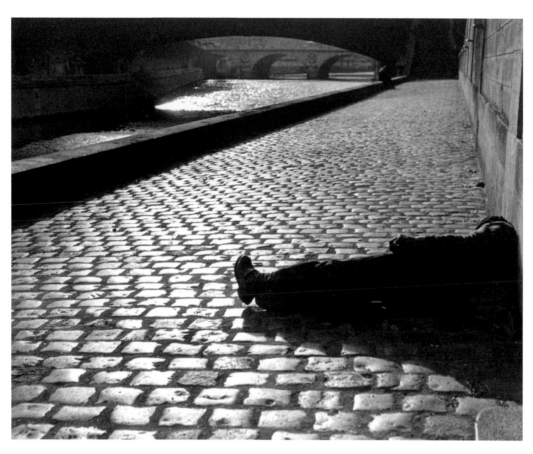

Paris – by the Seine, Paris, 1952

Bullring, Spain, 1978

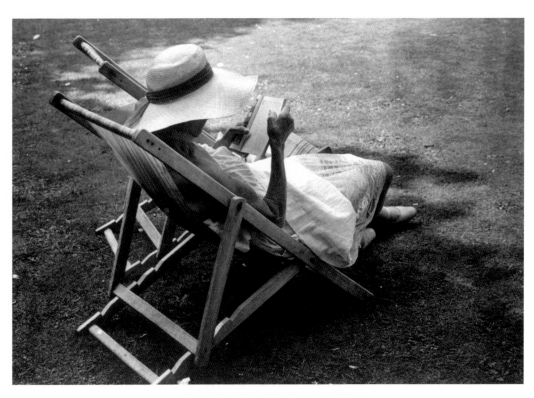

Woman Reading, Bath, England, 1975

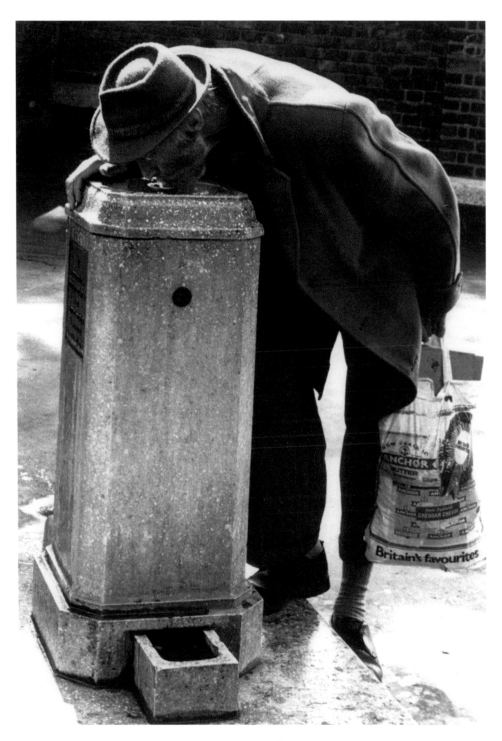

Man at Fountain, England, 1975

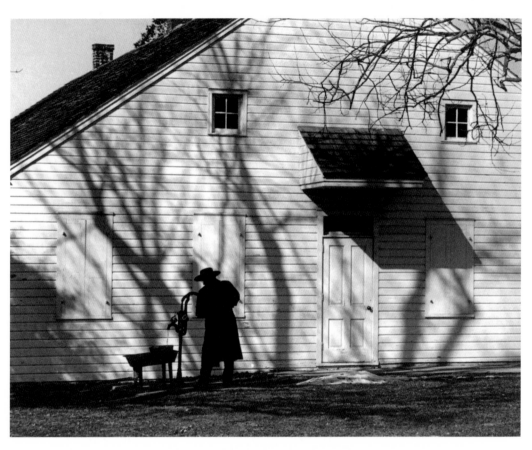

Mennonite at Pump, Pennsylvania, 1981

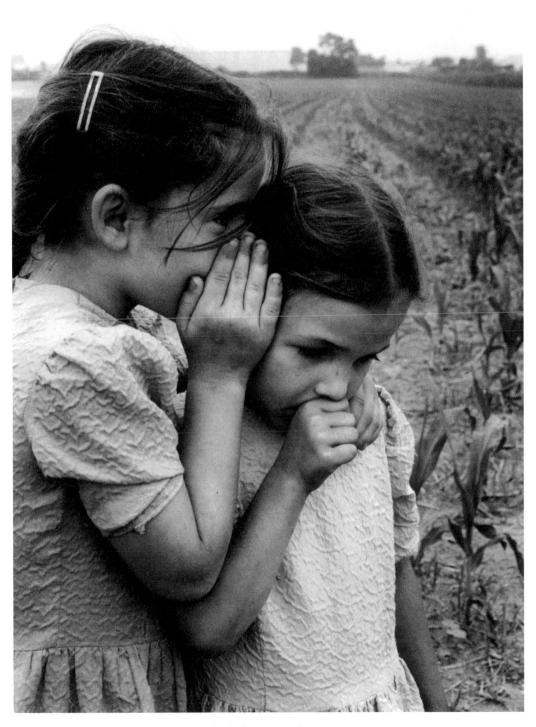

Amish Children, Pennsylvania, 1981

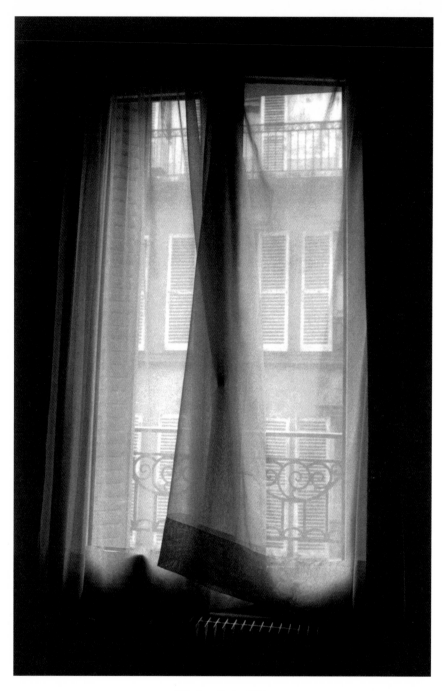

Window, Paris, 1981

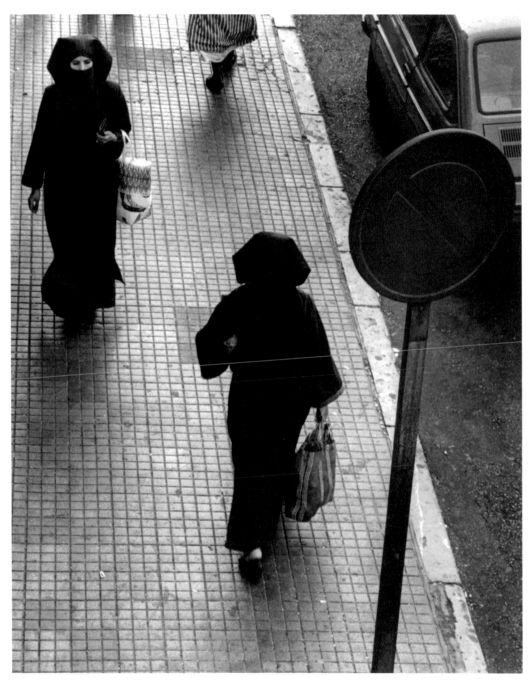

Moroccan Double Take, Morocco, 1978

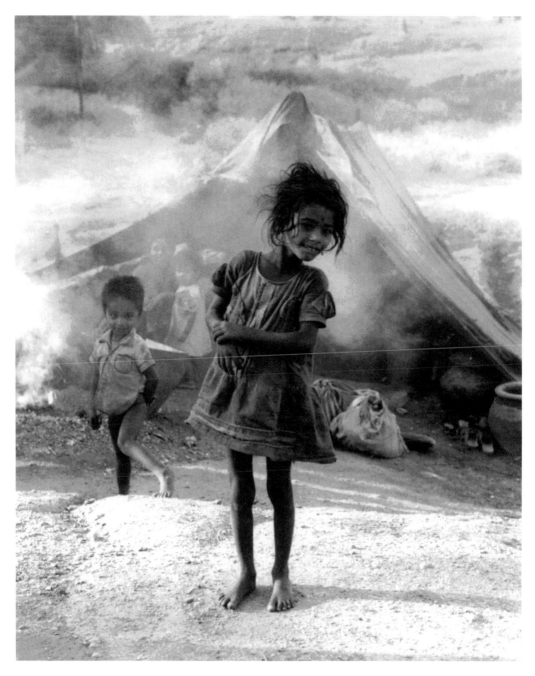

Child at Home, India, 1984

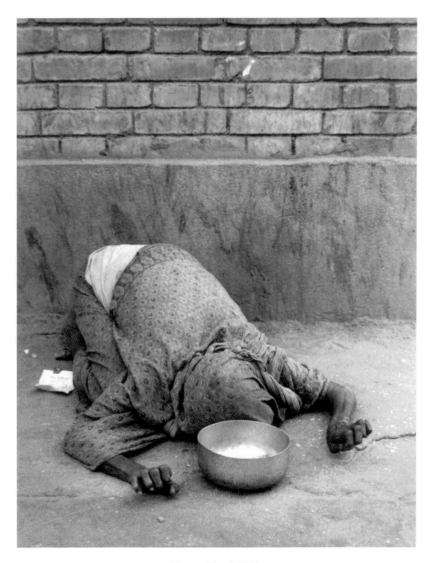

Beggar, Nepal, 1984

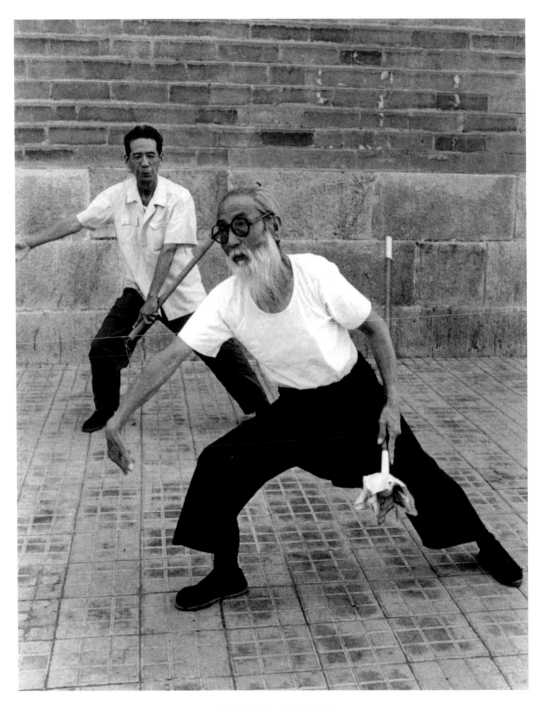

Tai Chi, Shanghai, 1982

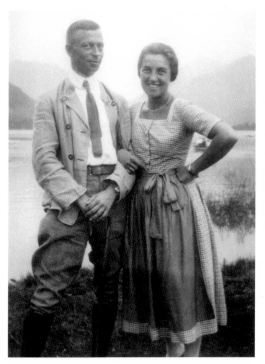

Fritz M. and Elisabeth Klopfer, ca. 1920

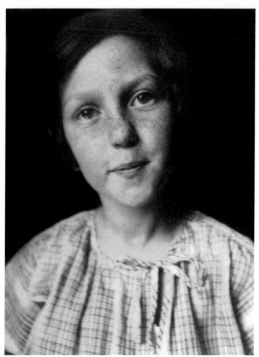

Fritz M. Klopfer: Erika, ca. 1930

Erika Klopfer, ca. 1942

Tina Ruesinger: Erika Stone, 1998

Interview with Erika Stone

Sibylle Appuhn-Radtke talked to the photographer in December 2000.

You spent most of your childhood in Munich. Can you describe your earliest memories of living there?

My early childhood years in Munich were happy ones. My family was fairly well off and we lived in a large apartment on the Arcisstraße [now Meiserstraße]. We had a "Kinderfräulein" and a cook. While my father worked as "Syndikus" [corporate lawyer] at BMW, my mother had her own activities. We were mostly supervised by our "Kinderfräulein". (I was still corresponding with Jula, our last governess until she died less than a year ago.) We had a number of friends to play with and attended the Luisenschule, nearby. Generally, we were happy and enjoyed our vacations in the Allgäu or on one of the lakes. Much changed when Hitler came into power.

You were a schoolgirl in the "Capital of the Movement" when the National Socialists took over power in 1933. You couldn't know then the far-reaching consequences that this event was to have for your family. Can you remember how you experienced the party's public activities in Munich? Do the party headquarters in the Meiserstraße – where your exhibition is being held in March 2001 – play any part in your childhood recollections?

Since we did not know that our background was Jewish and had been brought up as Protestants, we were thrilled, along with our friends, with all the parades and activities when Hitler came to power. We begged my parents to let us join the Hitler Youth, but they never explained why they would not let us nor did they tell us that we were of Jewish descent. However, the atmosphere in Munich and in my family changed. I often had "das Arme Tier", as my mother called it, a depressed feeling. We had to move to a smaller apartment in Schwabing, had to change to a private school and were no longer allowed to have servants. However, I can remember standing on my grandfather's [the lawyer Eduard Maximilian Bloch] office balcony greeting Hitler when he paraded by. Before we had to move, we lived near all the Nazi buildings, where many of the activities took place. Once we were crossing the big Königsplatz next to our house [which had been transformed into a Nazi parade ground], on the way to school and two SA men pointed their guns at us and told us we could not pass. My sister got very scared and ran home, crying.

That sounds as if you had as a child no idea at all of the cause and effects of the restrictions on your family. Were you really not aware of the discrimination against Jewish citizens?

We knew very little. My parents protected us from all the news and since we felt we had no connection to the Jewish community and were too young to understand much we escaped this burden.

In some articles on your life it is said that the emigration was a shock for you because your parents didn't tell you and your sister what sort of journey you were really going to make. Did this experience have an effect on your relationship to Germany and the city of your childhood?

Coming to America was not so much a shock, as a surprise. Since we knew nothing about what was happening in Germany and since my parents sent us to a "Kinderheim" for about six months while they made plans to leave, we only learned about the move a few months before we left. We were told that our move to New York was only to be for a few years and that we would come home again. I don't feel that our emigration to the USA coloured my view of Munich. I very much enjoy visiting there. It is just that I love New York so much and enjoy my lifestyle there, as well as the big city atmosphere, that I know I could not live in Munich again.

You were given your first camera when you were ten years old. What subjects did you photograph with it?

My first camera was a little "Browny-like" camera. I don't remember the exact make. I photographed my friends, my parents and my grandmother. Apparently, I already had a good eye because I often framed the pictures with a branch in the foreground leading in to the subject. Everyone, even then, remarked on my photographs.

No doubt you had art classes at school. Photography was probably not part of the curriculum, but perhaps you can remember which artistic role-models were dealt with, which artists, which works?

I don't remember my art classes in Munich but I majored in art in high school here in New York. I was always drawn to paintings of people rather than nature or landscapes. Thus my favourites were the French Impressionists, such as Renoir, Manet, Degas, Toulouse-Lautrec and the Germans, such as Nolde, Kirchner, Beckmann, Kollwitz or Norway's Edvard Munch.

Can you tell us something about your arrival in the USA? Had you already learnt some English in Germany? How did you make your first friends in Riverdale?

We didn't know any English to speak of when we arrived here. On the ocean liner

on our way to the USA we befriended a little American girl. She spoke no German and my sister and I very little English but we got along fine. After we arrived in New York, we were almost immediately sent to school, not knowing English. The children were very nice to us and wanted to help, but I kept saying: "I do not understand English". We were put into lower grade classes and suddenly after a few months we knew some English. After a year we got along very well. When we moved to Riverdale, a suburb of New York, we went to a new school and soon made friends. We also went to the Presbyterian Church Sunday School and our social life developed.

Your second camera provided much better technical and artistic possibilities than the first. Did you experiment with it? Did you start trying to "design" your photos, or were you more concerned with a successful portrayal of your subjects?

My father gave me his Voigtländer Superb camera when I was a teenager and I was soon using it constantly. I photographed neighbourhood children and sold the pictures to their parents in order to raise money for film and chemicals. I also loved walking the streets of certain areas of the city, especially Harlem, Greenwich Village and the Lower East Side of New York. I always photographed people. There was little crime in those days and everyone, especially the minorities, were friendly and loved to be photographed. Very different to later, when drugs pervaded the city. I really developed as a photojournalist with an interest in human beings and was not so much a planner of pictures. So I tried to catch my subjects unaware of me. I was more a "taker" of pictures rather than a "maker" of pictures.

How did you come across "The New York Photo League"?

I needed a darkroom after my mother threw me out of the bathroom, which I had used for developing my films. She didn't like the chemical stains and smells. So I had to find another place. A friend suggested "The New York Photo League", an organization of idealistic photographers who wanted to use the medium for the betterment of the world. This was just what I wanted to do, too. I had to join in order to use their darkroom and soon was drawn in by their ideals and attended meetings.

Can you tell us something about the well-known photographers of the Photo League, for example Weegee?

I met many photographers who later became well-known. Weegee, whose real name was Arthur Fellig, was a real character who was always after all the young girls, including me. He was a fairly old man who always wore a hat and had a cigar in his mouth. He lived above a police station and was always on the scene when something happened in

the city. He usually photographed the people on the fringes of the action, such as at a fire or a murder. His pictures are now very valuable. I am still friends with Morris Engel, who together with his then wife, Ruth Orkin, made the film "The Little Fugitive". Walter Rosenblum, too, is still alive and was a great documentary photographer.

You studied for a while under Berenice Abbott, an influential photographer. Do you recall any aspects of her view of photography that she felt were particularly important? Did you adopt any of them in your own perception of photography?

Berenice Abbott gave a course at the New School of Social Research in Greenwich Village and I decided to attend. I am certain I gained much from her class but I don't remember many details. I admired her work on New York City buildings and streets but did not have the ambition to carry a large format camera and tripod as she did. I was much more of a snapshooter. She also did great portraits and I always visit exhibitions of her work.

Your photos from the poor neighbourhoods of New York City are an indication that you were prepared to take personal risks to obtain a particular shot. What was your motivation to do this?

I have always been rather adventurous and a risk-taker. I had little fear of human beings ... I was more afraid of nature. I guess it was my photojournalistic instinct that made me go to these somewhat more dangerous areas. But they weren't really so very dangerous in the 40s and 50s. Black people were very religious and the anger they developed later on had not yet evolved. I loved talking to them and finding out more about their lives.

Of course it can sometimes be a problem to take photographs of someone who is not aware of it. I once had doubts that one of my photographs was perhaps a bit indiscreet: a photograph of a man and his dog taken some years ago in Central Park was published with the title "Look-A-Likes" in a book called *Women Photograph Men* (ill. p. 29). Soon after, I received a call from the gentleman in the photograph asking if he could come and see me. I was worried that he was offended by my picture caption, but when he arrived, he kissed my hand in the manner typical of Austrians and raved about the photograph. He told me that he was really pleased that I thought he and his dog looked alike.

He had only one wish, an enlargement of the picture, which I printed up and immediately sent to him. A few years later, I came across his obituary in the newspaper. Since his wife was a well-known *New York Times* columnist, I sent her a letter of condolence. Soon after, came a beautiful reply telling me that the photograph had given her husband tremendous pleasure, especially since his dog preceded him in death by a year. The framed picture still has a treasured place on the piano.

Photoreportages of important public events make completely different demands on a young photojournalist. Were there any situations in your early journalistic career where you first had to find your feet?

One amusing experience was as follows: Max Peter Haas, who was my boss at the European Picture Service, asked me to accompany him to the tennis championships at Forest Hills. Having never covered tennis before, I wore a low-cut, pink dress and high heeled shoes: not the most appropriate attire for covering a tennis match, I found out. While sitting in the press box, Mr Haas suggested that I get out on the court with the Rolleiflex and get some shots of the players warming up. As soon as I stepped out on the court in high heels, an official informed me that I could not go on the court in those shoes. Kicking them off, I concentrated on catching good action shots of the two Australians. I was all over the court, at times crouching or trying high angles when suddenly the whole stadium applauded. I thought that the clapping was for the players and paid no attention. Soon the Australians stopped and turned to me yelling "Hey, don't you know the crowd is applauding you?" Completely embarrassed I rushed off the court and for weeks following the event I met people who asked me if I really was "that girl" who made such a scene at Forest Hills.

Did you see the photography exhibition "The Family of Man" in the Museum of Modern Art in 1955? If so, were there any photographs there that made a particular impression on you?

Yes, I did see "The Family of Man" exhibition and was sad that I had not known about it earlier and that I was not as yet ready to show my work. I was very impressed with it and thought it was a wonderful documentation about the similarities of all beings and life experiences. I remember a few pictures: Brassaï's couple in a swing, kissing; Elliott Erwitt's mother and baby; Eisenstadt's children following a drum major or Ruth Orkin's children playing cards.

It seems to me to be typical of your work that three of the photos you remember from this exhibition are of children. You have been very active in trying to improve the social conditions in which children grow up, in particular for the introduction of the "SOS Kinderdorf" [village for neglected children] model in the USA. What first interested you in this and what were your experiences?

I had read about the "SOS Kinderdörfer" and was very impressed with the concept. I suggested a feature on them to our *Parents' Magazine*. They decided to send me to Austria and Germany to do the feature. I met Herr Gmeiner [Hermann Gmeiner, 1919-1986, the founder of the "Kinderdorf" organization] at the Imst village, where we both stayed at the guesthouse and had breakfast together. He begged me to help him get the

villages started in the USA and I, too, believed that they would be a great improvement on our system of foster care. I wrote many letters and made many calls but in this country the belief is that children belong to their natural parents and are only sent away temporarily. We do now have two childen's villages, one here in Florida and one near Chicago, but they are quite different from the ones in Europe. The children can always be taken away from their SOS foster mother and given back to the natural parent. After I lost my leg in a mugging thirteen years ago, I felt that it was a message that I ought to do more for homeless and suffering children and I became quite active with the organization. But it has not worked out the way I had hoped it would and I am very discouraged and no longer active in that direction.

You are the mother of two (grown-up) children yourself. How did you manage to combine your career and your family? Did you ever feel that it was a disadvantage to be a woman in photojournalism?

A year after I had my first son, I found running my small picture agency and being a photojournalist too difficult. There were times when my baby sitter didn't show up and I had to bring Michael along to the office. So the time came to give up the agency. I started freelancing from home, first photographing my own children, then their friends, parents and grandparents and I was able to sell the pictures to a number of baby and family magazines. This then became my business. I had a maid and babysitters a few times a week but was always there for my children in the mornings and evenings. It was a compromise to my photojournalistic work, which I loved, but at least I was still taking pictures. It grew into quite a large business and I supplied photos to most textbook publishers and family magazines. My husband was cooperative and helped me. He usually developed my film for me and sometimes assisted me on photo assignments. And my sons were great models.

You have taken pictures of famous people as well as unknown people from all walks of life and many different countries. Was the one your journalistic career and the other your passion, or would it be wrong to separate the two?

The first part of my career, photojournalism, was assignment work. Later, my travels and photographs of children were passion – passion for travel, for seeing and learning and for documenting. My husband and I took many trips and later I travelled with a friend whose husband also favoured European and familiar countries and didn't want to travel to more exotic places. So she and I travelled to China and Southeast Asia, India, South America, Scandinavia, South Africa and the Soviet Union. We are still travelling together and I still take pictures on these trips.

About your trips: how do you decide where you want to go? What makes a country interesting for you?

I am only interested in "peopled" places. My travelling companion often wants to go to more scenic places, such as Alaska or New Zealand but so far I have resisted. We recently visited Morocco ... great for my type of pictures. I would love to go back to Asia and Africa.

For even the most colourful scenes reproduced in this book you have only used black and white film. Why?

I have produced much colour work in my work with children, since that is what the publications want. Also on my travels, I do some colour work as well for commercial purposes. But I much prefer black and white for my own more artistic and documentary work.

Most of your work is characterised by a strict formal composition, yet you rarely take landscape or architectural photographs where corresponding structures can be more "purely" portrayed. What is the reasoning behind this?

As I mentioned before, I am not attracted to immobile structures, even if they make a good composition. They leave me cold. It is the uniqueness and diversity of man, woman and child which thrills me. It's people, their joys and sorrows, that I feel I must document and my camera will always seek them out.

If you were to start your career over again today, would you follow the same path or would you do something completely different?

I loved my life in photography. I would not change much. I did give up a bigger and more successful career in photojournalism to be a mother and wife but I am not sorry. I, most likely, would travel the same road again.

Biography

1924	Born in Frankfurt, father is the lawyer Fritz M. Klopfer (1886–1953), mother Elisabeth Klopfer, née Bloch (1894–1979).
1925	Father becomes company lawyer and deputy managing director of BMW in Munich. Family move to Munich, Arcisstraße 11.
1934	Erika given her first camera.
1936	Father made redundant, family emigrates to the USA. Family settle in Riverdale, N.Y. Erika starts using a *Voigtländer Superb* (medium-sized reflex camera).
from 1939	Contributes to family income with private portrait photographs of children.
from 1942	Works in *Lab Leco*, New York City, for the German immigrant Leo Cohn. Membership in the *New York Photo League*. Studies at the *New School for Social Research* under Berenice Abbott and George Tice. Purchase of a flash for first journalistic assignments. Assignments for the *Riverdale Press*.
1946	Photo reportage on the Bowery (appeared in *Vecko-Journalen* 28, Stockholm 1946).
from 1947	Portrait photographs of stars at the Tanglewood Music Festivals in Berkshire Hills.
1947–1953	Photos for *The European Picture Service*; photos published in *Time Magazine* and *Spiegel*.
1951	Winner of the *Life* magazine prize for young photographers.
1952	Trip to Europe. Photos of Pablo Casals at a festival in Prades/France.
1953–1959	Own picture agency with Anita Beer (*Photo Representatives*).
1954	Marriage to the author William Stone.
1958	Birth of son Michael.
from 1959	Photographic studies of children. Production of illustrated books.
1960	Birth of son David.
1978	Photos in Morocco.
1979	Illustrated books *On Divorce*, *The Adopted One* and *About Phobias* (Texts by Sara Bonnett Stein).
1980	Photos in Israel and Egypt. Reportage on *SOS Kinderdörfer* in Germany and Austria.
1982	Photos in China.
1982	Children's book *Nicole Visits an Amish Farm* (Text by Merle Good).
1984	Photos in India.
1986	Publication on how to photograph children: *Pro Techniques of Photographing: Children*. Photos in South America.
1987	Photos in Turkey.
1989	Photos in Scandinavia and Russia.
1995	Photos in South Africa.
1998	Photos in Malta.
2000	2nd trip to Morocco.

Exhibitions

1961 Parents' Magazine Gallery, New York City

1969 Parents' Magazine Gallery, New York City

1970 Modern Age Gallery, New York City

1979 Tanglewood Gallery, New York City

1980 Nassau Gallery, Princeton, N.J.

1981 Photographics Unlimited, New York City (The Me Generation)

1982 Neikrug Photographica, New York City (Woman of Vision)

1982 Floating Foundation of Photography, New York City (Woman of Vision)

1983 Photographics Unlimited, New York City (All the Children)

1983 International Center of Photography, New York City (Woman of Vision)

1985 Howland Center for Cultural Exchange, Beacon, N.Y. (Serendipity)

1985 Overseas Press Club, New York City (Children of the World)

1986 AIR Gallery, New York City (Woman Photographer NOW)

1988 The Library in Lenox, Mass.

1996 The Visual Fields Gallery in Rhinebeck, N.Y.

1997 The Visual Fields Gallery in Rhinebeck, N.Y. (Musical Celebrities – From the Past)

1997 The Museum of the City of New York, New York City (The Streets and Beyond)

1998 The Light Factory in Charlotte, N.C. (Women of the Photo League)

1998 Café Bondi, New York City

1999 The Art Gallery, University of New England, Maine (Faces)

1999 The Center of Creative Photography in Tucson, Arizona
(Looking into the Collection: Celebrity)

1999 The National Arts Club, New York City (PIA Annual Photography Show)

Bibliography

Dianora Niccolini (ed.): *Women of Vision*. Verona 1982, pp. 34–39.

Sharon Gill: "Erika Stone: A Varied Life in Photography", in: *Photo District News* 3, no. 7 (1983), p. 71ff.

Elfi Hartenstein: *Heimat wider Willen. Emigranten in New York – Begegnungen*. Berg am See 1991, pp. 312–323.

Lael Locke: "From Tanglewood to East Harlem: A Lifetime of Photography", in: *The Paper* (August 6, 1992), pp. 5–8.

Ellen Küppers: "Erika Stone: Fotografin für Life", in: *Aufbau*, 1993 (February 12, 1993), p. 24.

Ellen Küppers: *Emigranten in New York*. Munich 1995, pp. 33–47.

Thomas Honickel: "Alltagspoesie", in: *Schwarzweiß*, no. 18 (Dezember/November 1998), pp. 68–71.

Shawn O'Sullivan: "Erika Stone", in: *Black & White*, no. 9 (October 2000), pp. 106–109.

Elfi Hartenstein: "Erika Stone – Fotografin", in: *Ab 40* (January 2001), pp. 82–92.

Edited by Sibylle Appuhn-Radtke, Helmut Hess
and Christoph Hölz.
Translated into English by James Abram.

This book has been published in conjunction with the exhibition
"Erika Stone. Mostly People" at the Zentralinstitut für Kunst-
geschichte, Munich, March 2 – May 27, 2001.

Kehayoff Verlag
Herzogstraße 60
D-80803 München
Tel. +49 89 39 01 85
Fax +49 89 33 80 53
info@kehayoff.de
www.kehayoff.com

Kehayoff books are available worldwide. Please contact your nearest
bookseller or write to our address for information concerning your
local distributor.

Editing: Milena Greif
Design and Typesetting: Andrea Pfeifer, Munich
Printing: Lanadruck, Bozen

Printed and bound in Italy.

ISBN 3-934296-01-7